FRANCIS BACON

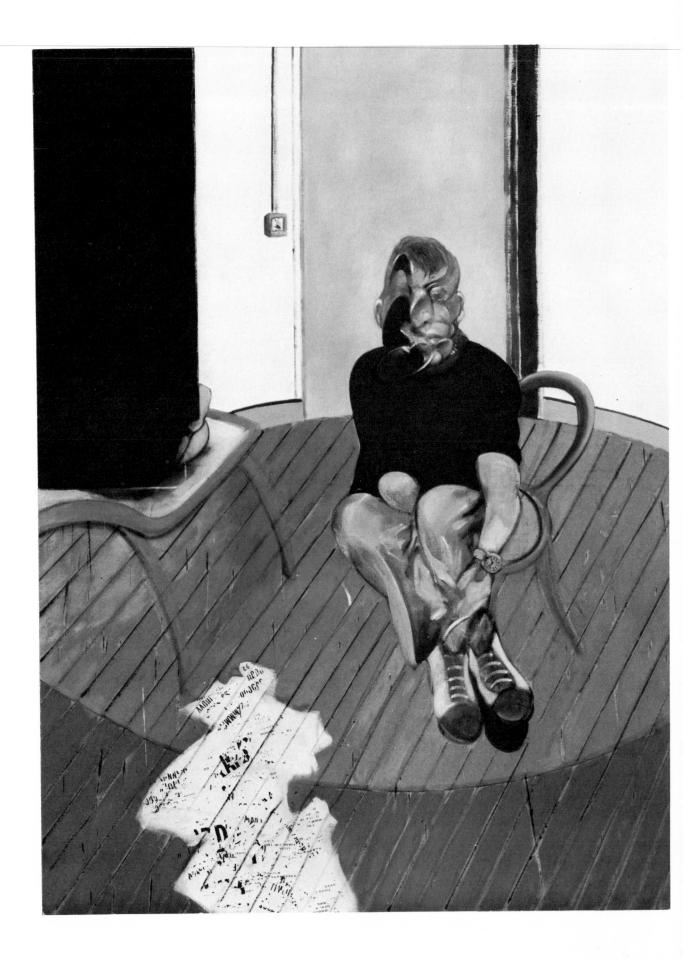

FRANCIS BACON

Interviewed by David Sylvester

With 94 black-and-white illustrations

PANTHEON BOOKS A DIVISION OF RANDOM HOUSE, NEW YORK

1 (Frontispiece) Self-Portrait 1973

Copyright © 1975 by David Sylvester

All rights reserved under International and Pan-American Copyright Conventions. Published in the United States by Pantheon Books, a division of Random House, Inc., New York, and simultaneously in Canada by Random House of Canada Limited, Toronto. Originally published in Great Britain as *Interviews* with Francis Bacon by Thames and Hudson, London.

Library of Congress Cataloging in Publication Data

Sylvester, David. Francis Bacon.

Bacon, Francis, 1909 Art—Philosophy.
Bacon, Francis, 1909 ND497.B16S9 1975 759.9415 74-26206
ISBN 0-394-49763-5
ISBN 0-394-73062-3 pbk.

Manufactured in the United States of America

FIRST AMERICAN EDITION

Contents

Preface	6
Interview 1 (October 1962)	8
Interview 2 (May 1966)	30
Interview 3 (December 1971, July 1973, October 1973)	68
Interview 4 (September 1974)	108
List of Illustrations	126

Editorial Note

Preface

Interviews based, as these are, on transcripts of tapes relate to interviews based on memory and notes as photography relates to painting. Tape, like the camera, cannot lie, and cannot discriminate. It faithfully records every false start, every crossing of purposes, every malformation of syntax and thought, every digression, every unthinking answer or question, every unwitting distortion of fact resulting from not having time to remember clearly. The transcript is rather like a sheet of contact prints where each shot registers the subject's behaviour at a certain moment but an overall sense of him eludes them all. In contrast, the interviewer who eschews mechanical aids and is thereby forced to select, discard and condense from the outset may manage to set down not so much what the subject happened to say as what he meant to say. (It is a consummation perhaps likeliest to come about in the kind of interview which never was an interview but is a synthesis composed from the remembrance of things said from time to time in the course of unmotivated conversation.)

But is the transcript necessarily beyond redemption? The interviewer ought, when editing, to be able to treat it as raw material, to proceed as a painter would when working from photographs – to use this aid with total ruthlessness, being responsible not to it but to what he knows about the subject. Yet the transcript is endowed with a crushing authority: this and only this really is what was said. It is not what one rather thinks, as one pours boiled water onto instant coffee powder in the morning, one heard the famous artist say last night over the second glass of the third bottle. It incontrovertibly is what he did say, the precise words he used more or

less precisely, more or less imprecisely. How, having his very words to hand, does one not treat them as holy writ? Tapes are traps. For despite ourselves we do rather believe that photographs get nearest to the truth.

Perhaps through lack of nerve, then, I have not attributed words to Francis Bacon in these edited scripts - all but one of which are based on several recording sessions - that are not present in the transcripts, except, of course, in making the minimal modifications needed to clarify syntax - and the aim of that operation has been precisely to clarify, not to tidy up, not to smother idiosyncrasy – and also very occasionally in altering a word to avoid its repetition or too opaque an ambiguity. But, if virtually nothing has been added, a great deal has been subtracted: perhaps threequarters of what is in the transcripts is absent from the edited scripts - not because of any arbitrary limitation on their length, but purely through editorial choice. Since the editing has been designed to present Francis Bacon's thoughts clearly and economically - not to provide some sort of abbreviated record of how the taped interviews happened to develop - the sequence in which things were said has been freely and radically rearranged: a paragraph in this montage may be built up from statements made on three different days. To make the montage not look like montage, questions have often been recast and sometimes fabricated. The aim has been to construct a more ordered, coherent and concise argument than the transcripts offer, without losing the fluid, spontaneous flavour of talk.

As to the problem of whether to insert, as in parliamentary reports, indications of where there was laughter, my conclusion was that, if one does this, one must also logically indicate whether each and every statement was made gravely, laconically, insistently, sarcastically, cautiously, patiently. I also decided against footnotes, believing that their owlishness might outweigh their usefulness. Nevertheless, there is one matter which I do think calls for a gloss: Bacon's uses of the word 'image'. Sometimes he uses it to mean a picture he is making or has made, or one by someone else, or a photograph; sometimes to mean a subject he has in mind or in front of him; sometimes to mean a complex of forms which has an especially powerful and suggestive resonance.

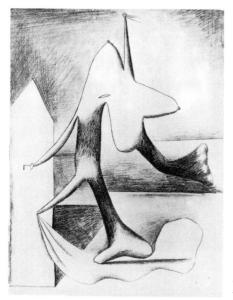

2 PICASSO Charcoal drawing 1927

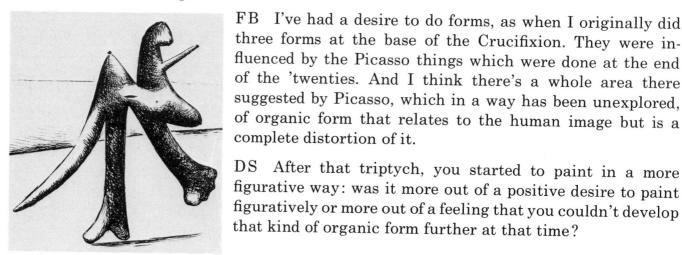

3 PICASSO Brush drawing 1927

4 Three Studies for Figures at the Base of a Crucifixion 1944

complete distortion of it.

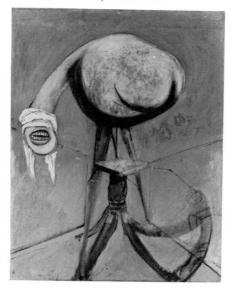

5 (Opposite) Centre panel of 4

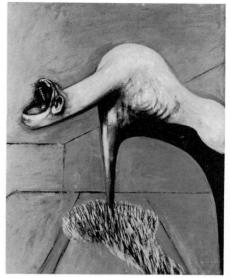

DSHave you ever had any desire at all to do an abstract painting?

FB I've had a desire to do forms, as when I originally did three forms at the base of the Crucifixion. They were influenced by the Picasso things which were done at the end of the 'twenties. And I think there's a whole area there

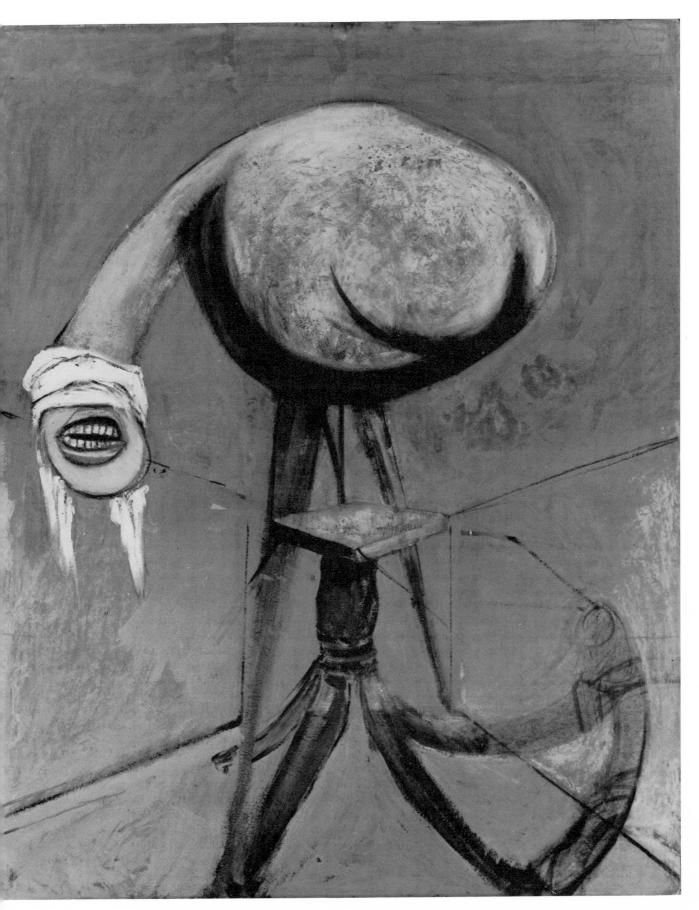

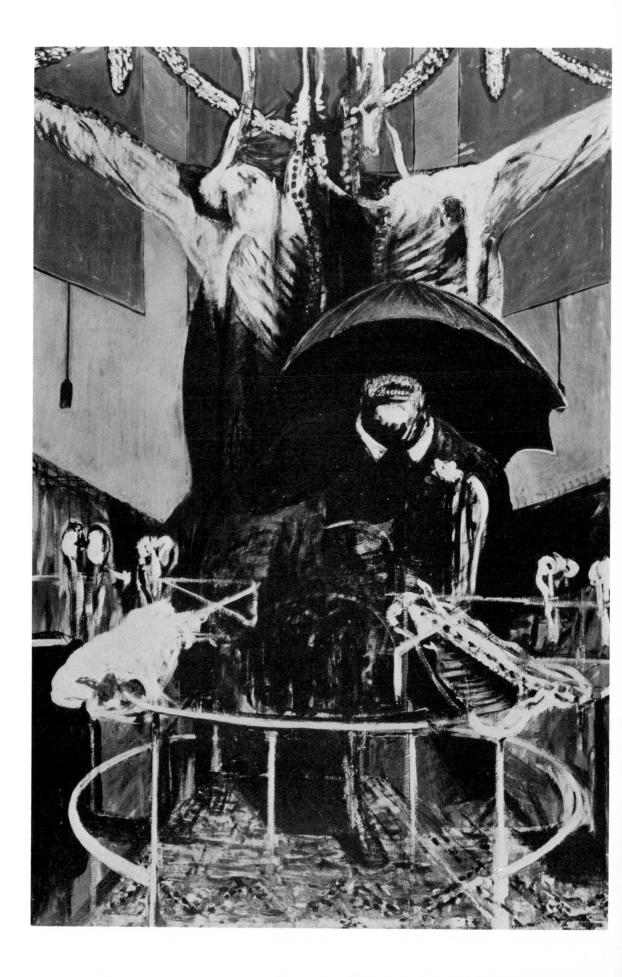

FB Well, one of the pictures I did in 1946, the one like a butcher's shop, came to me as an accident. I was attempting to make a bird alighting on a field. And it may have been bound up in some way with the three forms that had gone before, but suddenly the lines that I'd drawn suggested something totally different, and out of this suggestion arose this picture. I had no intention to do this picture; I never thought of it in that way. It was like one continuous accident mounting on top of another.

DS Did the bird alighting suggest the umbrella or what?

FB It suddenly suggested an opening-up into another area of feeling altogether. And then I made these things, I gradually made them. So that I don't think the bird suggested the umbrella; it suddenly suggested this whole image. And I carried it out very quickly, in about three or four days.

DS It often happens, does it, this transformation of the image in the course of working?

FB It does, but now I always hope it will arrive more positively. Now I feel that I want to do very, very specific objects, though made out of something which is completely irrational from the point of view of being an illustration. I want to do very specific things like portraits, and they will be portraits of the people, but, when you come to analyze them, you just won't know – or it would be very hard to see – how the image is made up at all. And this is why in a way it is very wearing, because it is really a complete accident.

7 Three Studies for Portrait of Henrietta Moraes 1963

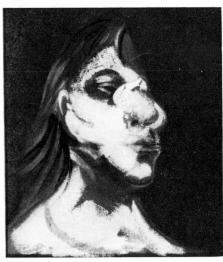

DS An accident in what sense?

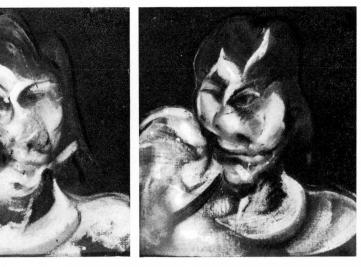

FB Because I don't know how the form can be made. For instance, the other day I painted a head of somebody, and what made the sockets of the eyes, the nose, the mouth were, when you analyzed them, just forms which had nothing to do with eyes, nose or mouth; but the paint moving from one contour into another made a likeness of this person I was trying to paint. I stopped; I thought for a moment I'd got something much nearer to what I want. Then the next day I tried to take it further and tried to make it more poignant, more near, and I lost the image completely. Because this image is a kind of tightrope walk between what is called figurative painting and abstraction. It will go right out from abstraction but will really have nothing to do with it. It's an attempt to bring the figurative thing up onto the nervous system more violently and more poignantly.

DS In those early paintings you've mentioned, there's a strong red or orange ground, but then the painting became altogether more tonal and for about ten years there were none of those large areas of violent colour.

FB So far as I can remember, I had a feeling that I could make these images much more poignant in the darkness and without colour.

DS And can you remember what made you start using strong colour again?

FB I suppose just getting bored.

DS Also, when the paintings got darker, the forms became less defined, more smudged.

FB Well, you can lose the form more easily in darkness, can't you?

DS Now, in some of your most recent paintings you've both been using strong background colours and gone back to the precise and sculptural sort of forms of that early triptych (4) – especially in the right-hand canvas of the new *Crucifixion* triptych. Do you have a general desire now to make the form more clear and precise?

FB Oh yes, the clearer and more precise the better. Of course, how to be clear and precise is a terribly difficult thing now. And I think that's the problem for all painters now, or at any rate painters who are absorbed in a subject or in a figurative thing. They just want to make it more and more precise; but of a very ambiguous precision.

DS In painting this *Crucifixion*, did you have the three canvases up simultaneously, or did you work on them quite separately?

FB I worked on them separately and, gradually, as I finished them, I worked on the three across the room together. It was a thing that I did in about a fortnight, when I was in a bad mood of drinking, and I did it under tremendous hangovers and drink; I sometimes hardly knew what I was doing. And it's one of the only pictures that I've been able to do under drink. I think perhaps the drink helped me to be a bit freer.

DS Have you been able to do the same in any picture that you've done since?

FB I haven't. But I think with great effort I'm making myself freer. I mean, you either have to do it through drugs or drink.

DS Or extreme tiredness?

FB Extreme tiredness? Possibly. Or will.

DS The will to lose one's will?

FB Absolutely. The will to make oneself completely free. Will is the wrong word, because in the end you could call it despair. Because it really comes out of an absolute feeling of it's impossible to do these things, so I might as well just do anything. And out of this anything, one sees what happens.

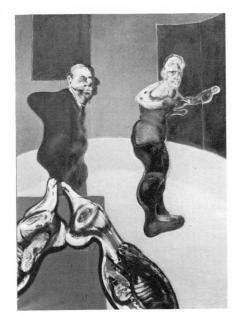

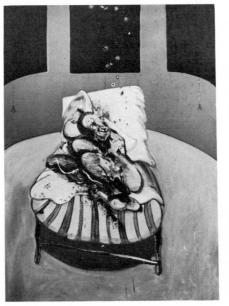

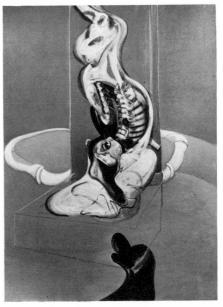

8 Three Studies for a Crucifixion 1962

DS Did the actual placing of the figures change while you were doing this triptych, or did you see them where they are before you started painting?

FB I did, but they did change continuously. But I did see them, and the figure on the right is something which I have wanted to do for a long time. You know the great Cimabue Crucifizion? I always think of that as an image – as a worm crawling down the cross. I did try to make something of the feeling which I've sometimes had from that picture of this image just moving, undulating down the cross.

DS And of course this is one of a number of existing images you've used.

FB Yes, they breed other images for me. And of course one's always hoping to renew them.

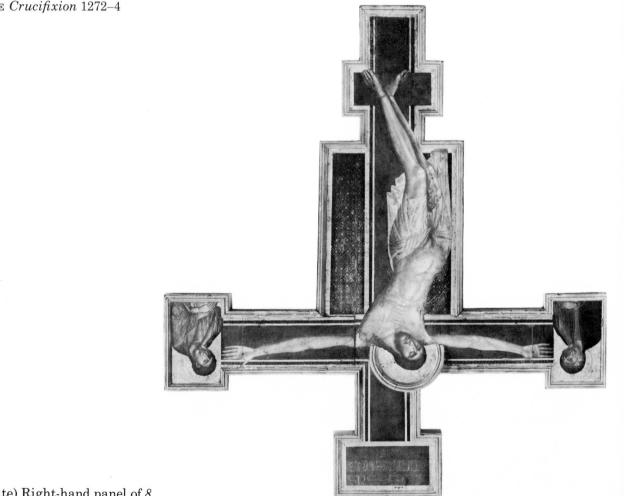

9 CIMABUE Crucifixion 1272-4 (inverted)

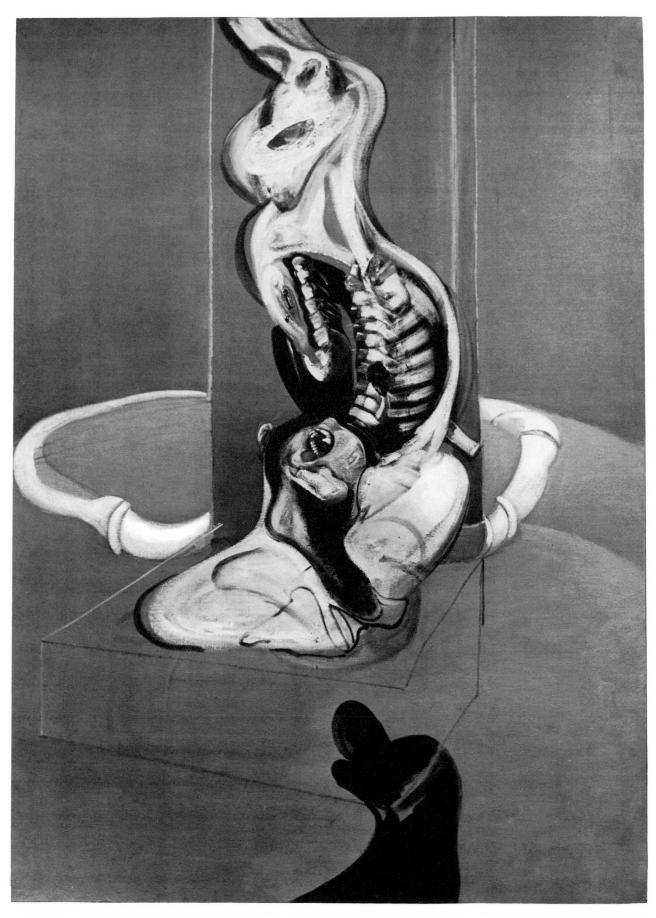

11 Study for Portrait of Van Gogh II 1957

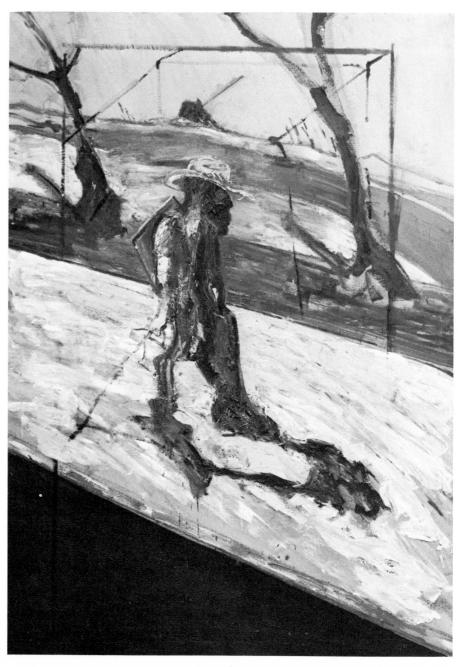

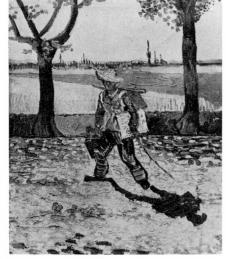

12 VAN GOGH The Painter on his Way to Work 1888

DS And they do get very transformed. But can you generalize about how far you foresee these transformations of existing images before you begin a canvas and how far they happen in the course of painting?

FB You know in my case all painting – and the older I get, the more it becomes so – is accident. So I foresee it in my mind, I foresee it, and yet I hardly ever carry it out as I foresee it. It transforms itself by the actual paint. I use very large brushes, and in the way I work I don't in fact know very often what the paint will do, and it does many things which are very much better than I could make it do. Is that an accident? Perhaps one could say it's not an accident, because it becomes a selective process which part of this accident one chooses to preserve. One is attempting, of course, to keep the vitality of the accident and yet preserve a continuity.

DS What is it above all that happens with the paint? Is it the kind of ambiguities that it produces?

 \mathbf{FB} And the suggestions. When I was trying in despair the other day to paint that head of a specific person, I used a very big brush and a great deal of paint and I put it on very, very freely, and I simply didn't know in the end what I was doing, and suddenly this thing clicked, and became exactly like this image I was trying to record. But not out of any conscious will, nor was it anything to do with illustrational painting. What has never yet been analyzed is why this particular way of painting is more poignant than illustration. I suppose because it has a life completely of its own. It lives on its own, like the image one's trying to trap; it lives on its own, and therefore transfers the essence of the image more poignantly. So that the artist may be able to open up or rather, should I say, unlock the valves of feeling and therefore return the onlooker to life more violently.

DS And when you feel that the thing, as you say, has clicked, does this mean that it's given you what you initially wanted or that it's given you what you'd like to have wanted?

FB One never, of course, I'm afraid, gets that. But there is a possibility that you get through this accidental thing something much more profound than what you really wanted.

DS When you were talking earlier about this head you were doing the other day, you said that you tried to take it further and lost it. Is this often the reason for your destroying paintings? That's to say, do you tend to destroy paintings early on or do you tend to destroy them precisely when they've been good and you're trying to make them better?

FB I think I tend to destroy the better paintings, or those that have been better to a certain extent. I try and take them further, and they lose all their qualities, and they lose everything. I think I would say that I tend to destroy all the better paintings.

DS Can you never get it back once it's gone over the top?

FB Not now, and less and less. As the way I work is totally, now, accidental, and becomes more and more accidental, and doesn't seem to behave, as it were, unless it is accidental, how can I recreate an accident? It's almost an impossible thing to do.

DS But you might get another accident on the same canvas.

FB One might get another accident, but it would never be quite the same. This is the thing that can probably happen only in oil paint, because it is so subtle that one tone, one piece of paint, that moves one thing into another completely changes the implications of the image.

DS You wouldn't get back what you'd lost, but you might get something else. Why, then, do you tend to destroy rather than work on? Why do you prefer to begin again on another canvas?

FB Because sometimes it disappears completely and the canvas becomes completely clogged, and there's too much paint on it – just a technical thing, too much paint, and one just can't go on.

DS Is it because of the particular texture of the paint?

FB I work between thick and thin paint. Parts of it are very thin and parts of it are very thick. And it just becomes clogged, and then you start to put on illustrational paint.

DS What makes you do that?

FB Can you analyze the difference, in fact, between paint which conveys directly and paint which conveys through illustration? This is a very, very difficult problem to put into words. It is something to do with instinct. It's a very, very close and difficult thing to know why some paint comes across directly onto the nervous system and other paint tells you the story in a long diatribe through the brain.

DS Have you managed to paint any pictures in which you did go on and on and the paint got thick and you still pulled them through?

FB I have, yes. There was an early one of a head against curtains. It was a small picture, and very, very thick. I worked on that for about four months, and in some curious way it did, I think, perhaps, come through a bit.

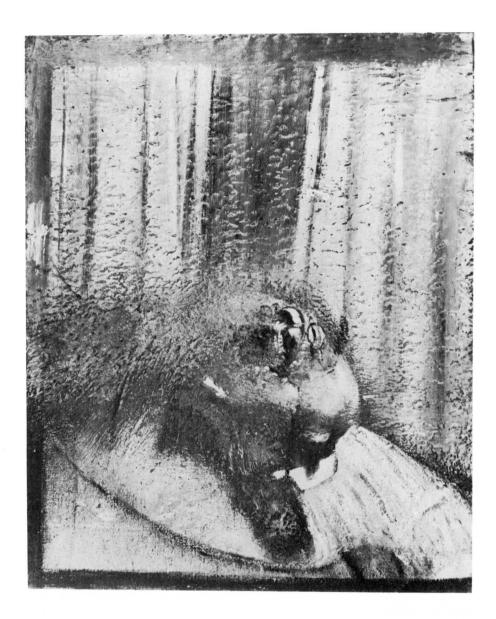

13 Head II 1949

DS But you don't often manage to work on a painting as long as that?

FB No. But now I find I can work more on paintings. And I hope to be able to have the first instinctive kind of basic thing and then to be able to work on almost directly, as though one was painting a new picture. I've been trying to work that way recently. And I think there are all sorts of possibilities in working directly first and then afterwards bringing this thing that has happened by accident to a much further point by will.

DS Can you ever turn a painting face to the wall and resume working on it a few weeks or a few months later?

FB I can't. It has a hypnotic effect upon me, and I can't

leave it alone, so I'm always very glad actually – which is a very bad thing – to try and finish them and get them out of the place as soon as possible.

DS If people didn't come and take them away from you, I take it, nothing would ever leave the studio; you'd go on till you'd destroyed them all.

FB I think so, yes.

DS Have you any positive urge to show them to people? Would it matter to you if they were never seen?

FB It wouldn't. No. Of course, it's true there are a very, very few people who could help me by their criticism, and I would be very pleased if they liked them at all. But otherwise I don't really care much.

DS Do you regret the ones you know were good and which you destroyed? Would you like to be able to see them again?

FB One or two. Yes, a very few I would be very pleased to see again. You see, if they have any quality, they leave memory traces in me which I've never been able to recapture.

DS Do you ever try to do them again?

FB I don't. No.

DS And you never work from sketches or drawings, you never do a rehearsal for the picture?

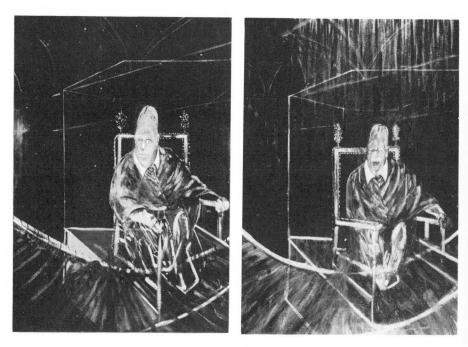

Pope I 1951
Pope II 1951
Pope III 1951

FB I often think I should, but I don't. It's not very helpful in my kind of painting. As the actual texture, colour, the whole way the paint moves, are so accidental, any sketches that I did before could only give a kind of skeleton, possibly, of the way the thing might happen.

DS And I take it that this also has to do with scale – that to work on a smaller scale for something on a larger scale would be pointless for you.

FB I think probably.

DS Actually, your scale is very consistent. Almost everything you paint is pretty well to the same scale. Your smaller paintings are of heads and, when you paint a large painting, it's of a full-length figure: the head in the large painting is the same size as the head in the small one. There are very few cases of a whole figure done in a small painting.

FB Well, that's my drawback, that's my rigidness.

DS And the scale is near that of life. So that, when you do a figure, the picture is large, which displeases the collectors.

FB Yes, but my pictures are not very large compared to so many modern paintings nowadays.

DS But they seemed to be so ten years ago when everybody was asking you to paint small pictures.

FB Not any longer. They look rather small pictures now.

DS You paint a lot in series, of course.

FB I do. Partly because I see every image all the time in a shifting way and almost in shifting sequences. So that one can take it from more or less what is called ordinary figuration to a very, very far point.

DS When you're doing a series, do you paint them one after the other or do you work on them concurrently?

FB I do them one after the other. One suggests the other.

DS And does a series remain a series for you after you've finished working on it? That's to say, would you like the pictures to be kept together, or is it all the same to you if they get separated?

FB Ideally, I'd like to paint rooms of pictures with different subject-matter but treated serially. I see rooms full of paintings; they just fall in like slides. I can daydream all

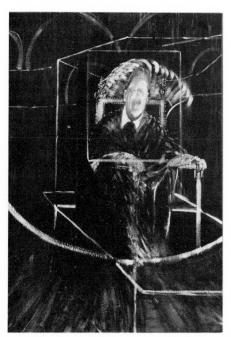

day long and see rooms full of paintings. But whether I ever make them really like what drops into my mind, I don't know, because, of course, they fade away. Of course, what in a curious way one's always hoping to do is to paint the one picture which will annihilate all the other ones, to concentrate everything into one painting. But actually in the series one picture reflects on the other continuously and sometimes they're better in series than they are separately because, unfortunately, I've never yet been able to make the one image that sums up all the others. So one image against the other seems to be able to say the thing more.

DS Most of your paintings have been of single figures or single heads, but in the new *Crucifixion* triptych you've done a composition with several figures (8). Would you like to do that more often?

FB I find it so difficult to do one figure that that generally seems enough. And, of course, I've got an obsession with doing the one perfect image.

DS Which would have to be a single figure?

FB In the complicated stage in which painting is now, the moment there are several figures – at any rate several figures on the same canvas – the story begins to be elaborated. And the moment the story is elaborated, the boredom sets in; the story talks louder than the paint. This is because we are actually in very primitive times once again, and we haven't been able to cancel out the story-telling between one image and another.

DS And it is true that people have been trying to find a story in the *Crucifixion* triptych. Is there in fact any explanation of the relationship between the figures?

FB No.

DS So it's the same thing as when you've painted heads or figures inside a sort of space-frame and it's been supposed that you were picturing someone imprisoned in a glass box.

FB I use that frame to see the image – for no other reason. I know it's been interpreted as being many other things.

DS Like when Eichmann was in his glass box and people were saying your paintings had prophesied this image.

FB I cut down the scale of the canvas by drawing in these

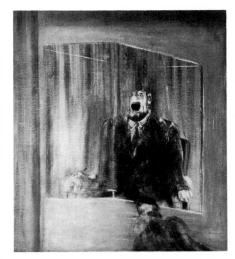

17 Study for Portrait 1949

rectangles which concentrate the image down. Just to see it better.

DS And it never ever had any sort of illustrative intention, not even in that painting of 1949 of a head with microphones?

FB No, it was just to be able to see the face and the microphones more clearly. I don't think it's a satisfactory device especially; I try to use it as little as possible. But sometimes it seems necessary.

DS And do the vertical breaks between the canvases of a triptych have the same sort of purpose as those frames within a canvas?

FB Yes, they do. They isolate one from the other. And they cut off the story between one and the other. It helps to avoid story-telling if the figures are painted on three different canvases. Of course, so many of the greatest paintings have been done with a number of figures on a canvas, and of course every painter longs to do that. But, as the thing's in such a terribly complicated stage now, the story that is already being told between one figure and another begins to cancel out the possibilities of what can be done with the paint on its own. And this is a very great difficulty. But at any moment somebody will come along and be able to put a number of figures on a canvas.

DS You may not want a story, but you certainly seem to want subjects with a lot of dramatic charge when you choose a theme like the Crucifixion. Can you say what impelled you to do the triptych?

FB I've always been very moved by pictures about slaughterhouses and meat, and to me they belong very much to the whole thing of the Crucifixion. There've been extraordinary photographs which have been done of animals just being taken up before they were slaughtered; and the smell of death. We don't know, of course, but it appears by these photographs that they're so aware of what is going to happen to them, they do everything to attempt to escape. I think these pictures were very much based on that kind of thing, which to me is very, very near this whole thing of the Crucifixion. I know for religious people, for Christians, the Crucifixion has a totally different significance. But as a nonbeliever, it was just an act of man's behaviour, a way of behaviour to another. 18 Velasquez Pope Innocent X 1650

19 Pope 1954

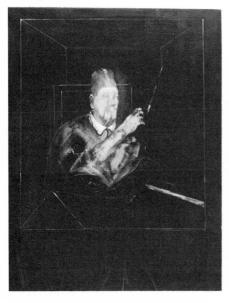

20 Study of Red Pope (Study from Innocent X) 1962

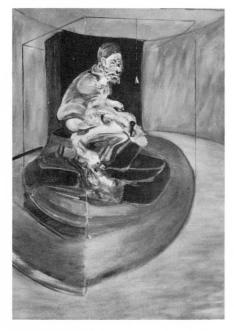

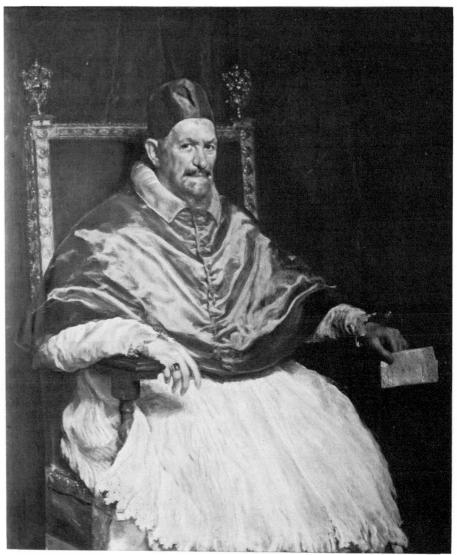

DS But you do in fact paint other pictures which are connected with religion, because, apart from the Crucifixion, which is a theme you've painted and returned to for thirty years, there are the Popes. Do you know why you constantly paint pictures which touch on religion?

FB In the Popes it doesn't come from anything to do with religion; it comes from an obsession with the photographs that I know of Velasquez's *Pope Innocent X*.

DS But why was it you chose the *Pope*?

FB Because I think it is one of the greatest portraits that have ever been made, and I became obsessed by it. I buy book after book with this illustration in it of the Velasquez *Pope*, because it just haunts me, and it opens up all sorts of feelings and areas of -I was going to say - imagination, even, in me.

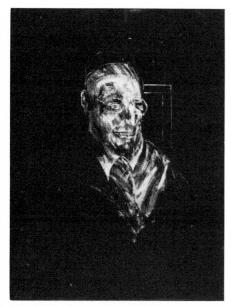

21 Study for a Head 1955

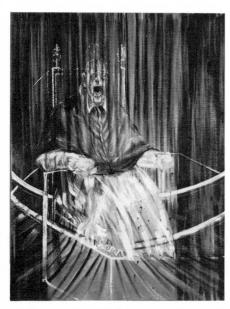

22 Study after Velasquez's Portrait of Pope Innocent X 1953

DS But aren't there other equally great portraits by Velasquez which you might have become obsessed by? Are you sure there's nothing special for you in the fact of its being a Pope?

FB I think it's the magnificent colour of it.

DS But you've also done two or three paintings of a modern Pope, Pius XII, based on photographs, as if the interest in the Velasquez had become transferred onto the Pope himself as a sort of heroic figure.

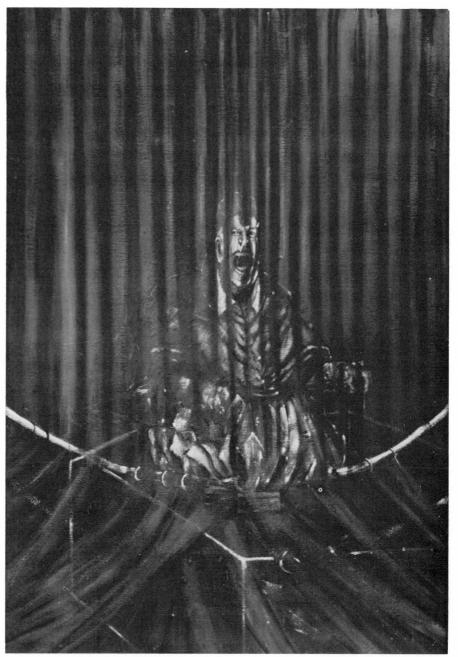

23 Study after Velasquez 1950

FB In those magnificent processional photographs when he was being carried through St Peter's. It is true, of course, the Pope is unique. He's put in a unique position by being the Pope, and therefore, like in certain great tragedies, he's as though raised onto a dais on which the grandeur of this image can be displayed to the world.

DS Since there's the same uniqueness, of course, in the figure of Christ, doesn't it really come back to the idea of the uniqueness and the special situation of the tragic hero? The tragic hero is necessarily somebody who is elevated above other men to begin with.

FB Well, I'd never thought of it in that way, but when you suggest it to me, I think it may be so.

DS Because those are the only themes of yours which touch on religion; there are no others. There's the crucified Christ and there's the Pope.

FB That is true. I think that what you suggest is probably true. It's because they have been forced by circumstances into a unique situation.

DS And is it the sort of mood implicit in some unique and possibly tragic situation that you want above all?

FB No. I think, especially as I grow older, I want something much more specific than that. I want a record of an image. And with the record of the image, of course, comes a mood, because you can't make an image without its creating a mood.

DS A record of an image you've seen in life?

FB Yes. Of a person, or a thing, but with me it's nearly always a person.

DS A particular person?

FB Yes.

DS But this was less so in the past?

FB Less so in the past, but now it becomes more and more insistent, only because I think that, by being anchored in that way, there is the possibility of an extraordinary irrational remaking of this positive image that you long to make. And this is the obsession: how like can I make this thing in the most irrational way? So that you're not only remaking the look of the image, you're remaking all the areas

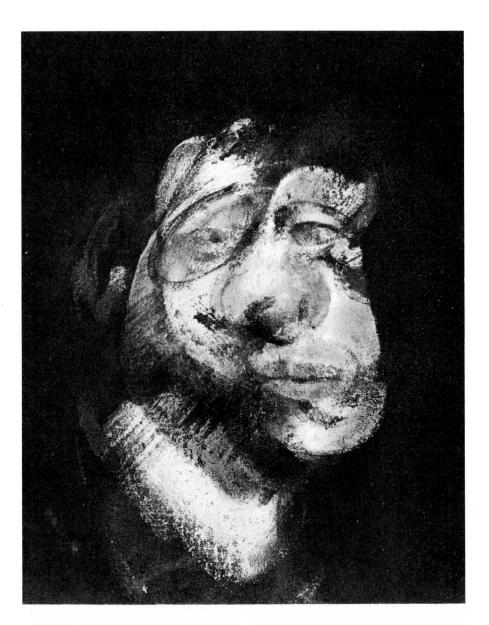

24 Centre panel of 25

25 Study for Three Heads 1962

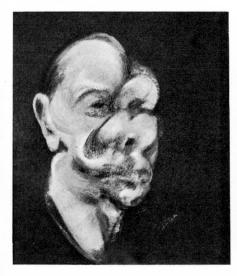

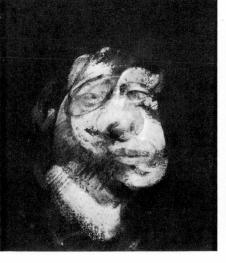

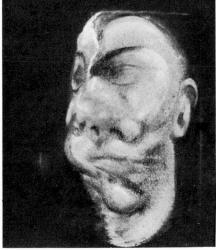

of feeling which you yourself have apprehensions of. You want to open up so many levels of feeling if possible, which can't be done in.... It's wrong to say it can't be done in pure illustration, in purely figurative terms, because of course it has been done. It has been done in Velasquez. That is, of course, where Velasquez is so different to Rembrandt, because, oddly enough, if you take the great late self-portraits of Rembrandt, you will find that the whole contour of the face changes time after time; it's a totally different face, although it has what is called a look of Rembrandt, and by this difference it involves you in different areas of feeling. But with Velasquez it's more controlled and, of course, I believe, more miraculous. Because one wants to do this thing of just walking along the edge of the precipice, and in Velasquez it's a very, very extraordinary thing that he has been able to keep it so near to what we call illustration and at the same time so deeply unlock the greatest and deepest things that man can feel. Which makes him such an amazingly mysterious painter. Because one really does believe that Velasquez recorded the court at that time and, when one looks at his pictures, one is possibly looking at something which is very, very near to how things looked. Of course the whole thing has become so distorted and pulled-out since then, but I believe that we will come back in a much more arbitrary way to doing something very, very like that – to being as specific as Velasquez was in recording an image. But of course so many things have happened since Velasquez that the situation has become much more involved and much more difficult, for very many reasons. And one of them, of course, which has never actually been worked out, is why photography has altered completely this whole thing of figurative painting, and totally altered it.

DS In a positive as well as a negative way?

FB I think in a very positive way. I think that Velasquez believed that he was recording the court at that time and recording certain people at that time; but a really good artist today would be forced to make a game of the same situation. He knows that the recording can be done by film, so that that side of his activity has been taken over by something else and all that he is involved with is making the sensibility open up through the image. Also, I think that man now realizes that he is an accident, that he is a completely futile being, that he has to play out the game without reason. I think that, even when Velasquez was painting, even when Rembrandt was painting, in a peculiar way they were still, whatever their attitude to life, slightly conditioned by certain types of religious possibilities, which man now, you could say, has had completely cancelled out for him. Now, of course, man can only attempt to make something very, very positive by trying to beguile himself for a time by the way he behaves, by prolonging possibly his life by buying a kind of immortality through the doctors. You see, all art has now become completely a game by which man distracts himself; and you may say it has always been like that, but now it's entirely a game. And I think that that is the way things have changed, and what is fascinating now is that it's going to become much more difficult for the artist, because he must really deepen the game to be any good at all. $\Box \Box$

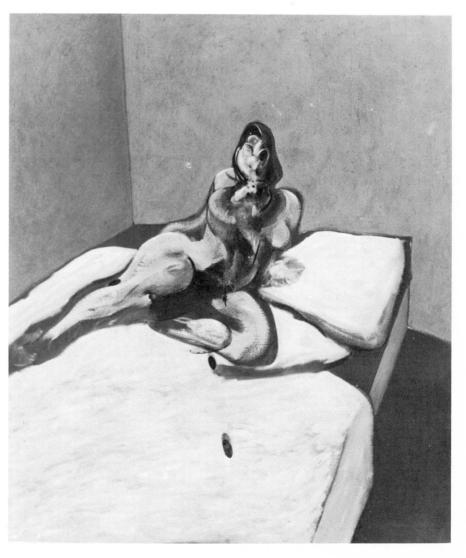

26 Portrait of Henrietta Moraes 1963

DS Can you say why photographs interest you so much?

FB Well, I think one's sense of appearance is assaulted all the time by photography and by the film. So that, when one looks at something, one's not only looking at it directly but one's also looking at it through the assault that has already been made on one by photography and film. And 99 per cent of the time I find that photographs are very much more interesting than either abstract or figurative painting. I've always been haunted by them.

DS Do you know what it is especially that haunts you about them? Is it their immediacy? Is it the surprising shapes that happen in them? Is it their texture?

FB I think it's the slight remove from fact, which returns me onto the fact more violently. Through the photographic image I find myself beginning to wander into the image and unlock what I think of as its reality more than I can by looking at it. And photographs are not only points of reference; they're often triggers of ideas.

DS I suppose that Muybridge's are the photographs you've made use of most continually.

FB Well, of course, they were an attempt to make a recording of human motion - a dictionary, in a sense. And the thing of doing series may possibly have come from looking at those books of Muybridge with the stages of a movement shown in separate photographs. I've also always had a book

27, 28 (Opposite) MUYBRIDGE Sequences of photographs from *The Human Figure in Motion* 1887

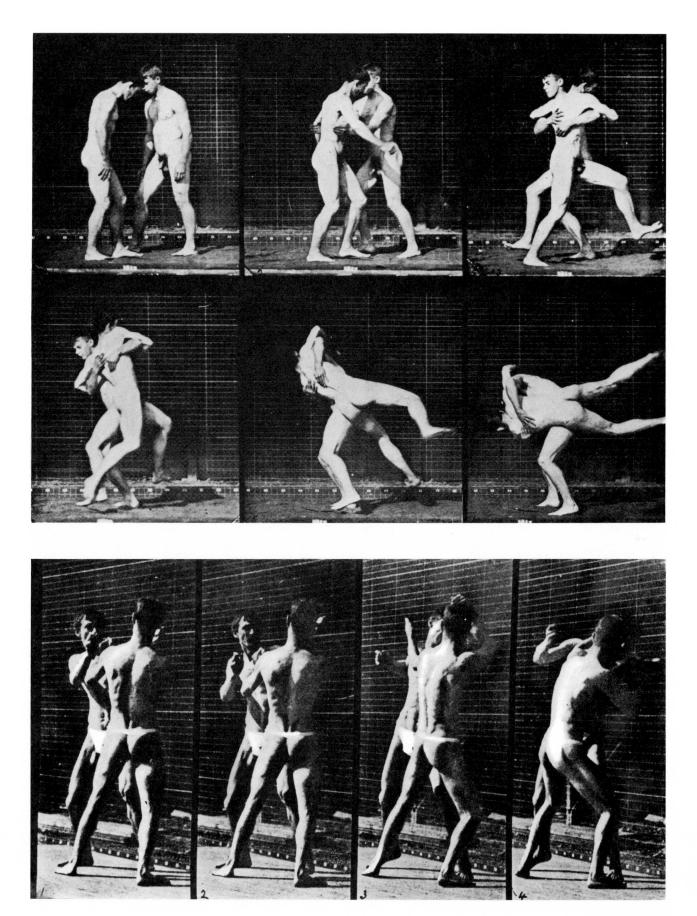

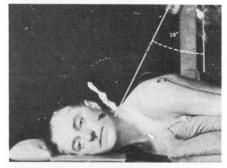

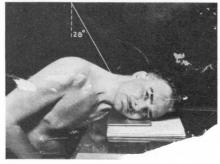

29 (Above) Series of photographs from K. C. CLARK, *Positioning in Radiography* 1929

30 (Right) CLEM HAAGNER Photograph taken in the Kalahari

31 (Opposite, above) MUYBRIDGE Page of selected photographs from *The Human Figure in Motion*

32 (Opposite, below) MARIUS MAXWELL Photograph from Stalking Big Game with a Camera in Equatorial Africa 1924 that's influenced me very much called *Positioning in Radio*graphy, with a lot of photographs showing the positioning of the body for the X-ray photographs to be taken, and also the X-rays themselves.

DS The influence, though, tends to be oblique – for instance, in that you'll often, while painting, be looking at a photograph of something quite other than the subject you're painting.

FB I think you've said somewhere that, when you were sitting for a portrait I was trying to do of you, I was always looking at photographs of wild animals.

DS Yes, I never knew quite how to take that.

FB Well, one image can be deeply suggestive in relation to another. I had an idea in those days that textures should be very much thicker, and therefore the texture of, for instance, a rhinoceros skin would help me to think about the texture of the human skin.

DS Of course, you did also use those photographs in a more literal way, in paintings of animals and some landscapes (53).

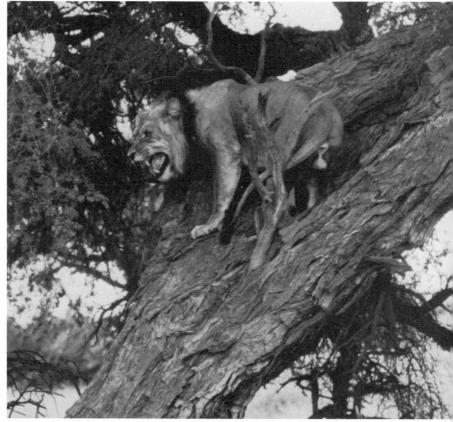

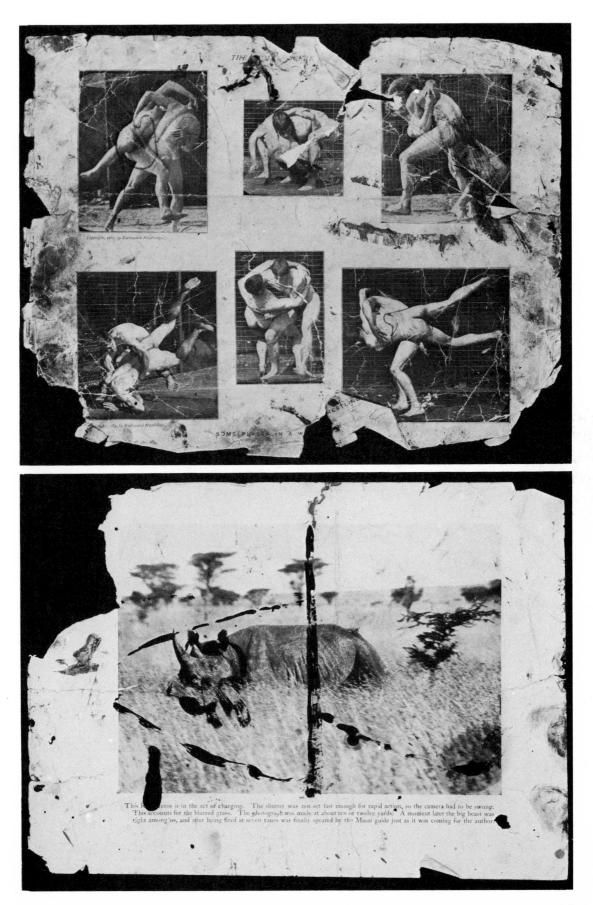

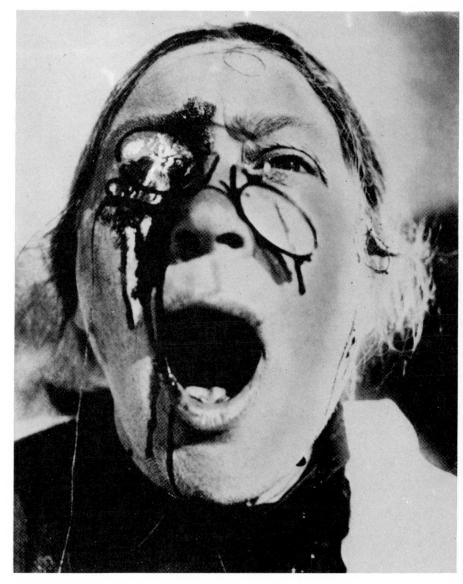

33 EISENSTEIN Still from The Battleship Potemkin 1925

> But it's interesting that the photographic image you've worked from most of all isn't a scientific or a journalistic one but a very deliberate and famous work of art – the still of the screaming nanny from *Potemkin*.

> FB It was a film I saw almost before I started to paint, and it deeply impressed me – I mean the whole film as well as the Odessa Steps sequence and this shot. I did hope at one time to make – it hasn't got any special psychological significance – I did hope one day to make the best painting of the human cry. I was not able to do it and it's much better in the Eisenstein and there it is. I think probably the best human cry in painting was made by Poussin.

DS In The Massacre of the Innocents?

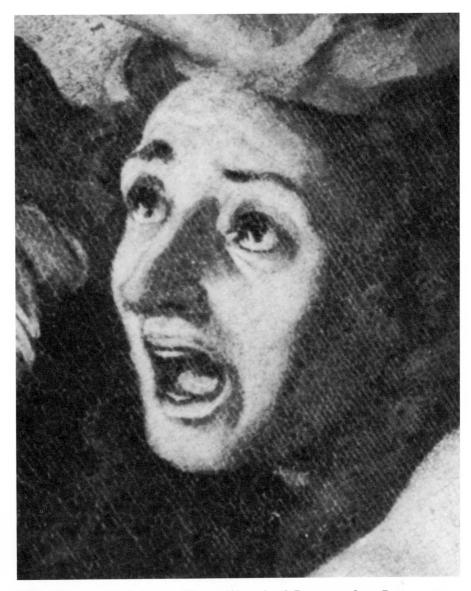

34 POUSSIN Detail from *The Massacre of the Innocents* 1630–31 (angle altered)

> Yes, which is at Chantilly. And I remember I was once FBwith a family for about three months living very near there, trying to learn French, and I went a great deal to Chantilly and I remember this picture always made a terrific impression on me. Another thing that made me think about the human cry was a book that I bought when I was very young from a bookshop in Paris, a second-hand book which had beautiful hand-coloured plates of diseases of the mouth, beautiful plates of the mouth open and of the examination of the inside of the mouth; and they fascinated me, and I was obsessed by them. And then I saw - or perhaps I even knew by then - the Potemkin film, and I attempted to use the Potemkin still as a basis on which I could also use these marvellous illustrations of the human mouth. It never worked out, though.

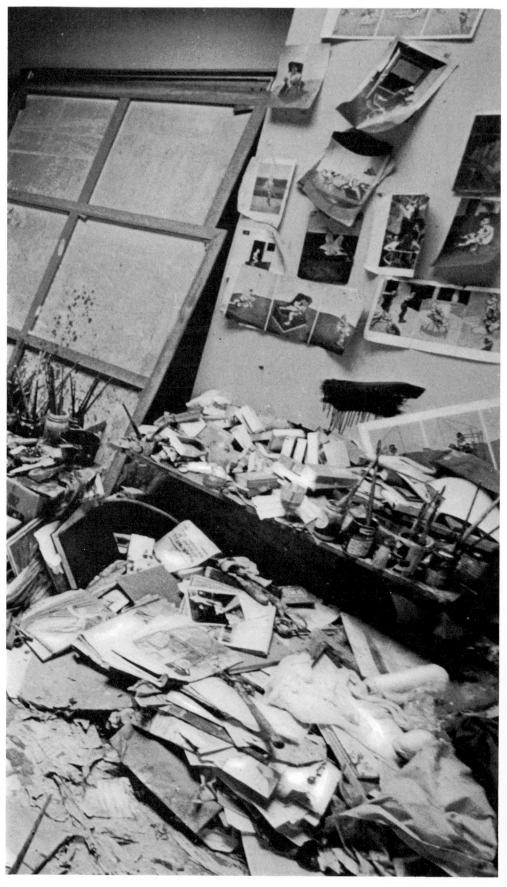

5 A corner of Bacon's studio

DS You've used the Eisenstein image as a constant basis and you've done the same with the Velasquez *Innocent X*, and entirely through photographs and reproductions of it. And you've worked from reproductions of other old master paintings. Is there a great deal of difference between working from a photograph of a painting and from a photograph of reality?

FB Well, with a painting it's an easier thing to do, because the problem's already been solved. The problem that you're setting up, of course, is another problem. I don't think that any of these things that I've done from other paintings actually have ever worked.

DS Not even any of the versions of the Velasquez Pope?

FB I've always thought that this was one of the greatest paintings in the world, and I've used it through obsession. And I've tried very, very unsuccessfully to do certain records of it – distorted records. I regret them, because I think they're very silly.

DS You regret them?

FB Well, I do, because I think that this thing was an absolute thing that was done and nothing more can be done about it.

DS You've stopped painting them now, have you?

FB I have.

DS There are some reproductions of your own paintings among all the photographs lying around the studio. Do you sometimes look at those while you're working?

FB Well, I do very often. For instance, I've been trying to use one image I did around 1952 (83) and trying to make this into a mirror so that the figure is crouched before an image of itself. It hasn't come off, but I very often find that I can work from photographs of my own works that have been done years before, and they become very suggestive.

DS I want to ask whether your love of photographs makes you like reproductions as such. I mean, I've always had a suspicion that you're more stimulated by looking at reproductions of Velasquez or Rembrandt than at the originals.

FB Well, of course, it's easier to pick them up in your own room than take the journey to the National Gallery, but I do nevertheless go a great deal to look at them in the National Gallery, because I want to see the colour, for one thing. But, if I'd got Rembrandts here all round the room, I wouldn't go to the National Gallery.

DS You'd like to have Rembrandts round the room?

FB I would. There are very few paintings I would like to have, but I would like to have Rembrandts.

DS Yet, when you finally went to Rome, though you stayed a couple of months, I think, you didn't take the opportunity to see the *Innocent X*.

FB I didn't. No. It's true to say that at that time I was extremely unhappy emotionally. And, though I loathe churches, I spent most of my time in St Peter's, just wandering around. But I think another thing was probably a fear of seeing the reality of the Velasquez after my tampering with it, seeing this marvellous painting and thinking of the stupid things one had done with it.

DS So there's clearly nothing in my suspicion. I think I must have supposed that you might prefer photographs to originals because they're less explicit, more suggestive.

FB Well, my photographs are very damaged by people walking over them and crumpling them and everything else, and this does add other implications to an image of Rembrandt's, for instance, which are not Rembrandt's.

DS Up to now we've been talking about your working from photographs which were in existence and which you chose. And among them there have been old snapshots which you've used when doing a painting of someone you knew. But in recent years, when you've planned to do a painting of somebody, I believe you've tended to have a set of photographs taken especially.

FB I have. Even in the case of friends who will come and pose, I've had photographs taken for portraits because I very much prefer working from the photographs than from them. It's true to say I couldn't attempt to do a portrait from photographs of somebody I didn't know. But, if I both know them and have photographs of them, I find it easier to work than actually having their presence in the room. I think that, if I have the presence of the image there, I am not able to drift so freely as I am able to through the photographic image. This may be just my own neurotic sense but

36 JOHN DEAKIN Photograph of George Dyer

37 Јонн Deakin Photograph of Isabel Rawsthorne

38 JOHN DEAKIN Photograph of Lucian Freud

> I find it less inhibiting to work from them through memory and their photographs than actually having them seated there before me.

DS You prefer to be alone?

FB Totally alone. With their memory.

DS Is that because the memory is more interesting or because the presence is disturbing?

FB What I want to do is to distort the thing far beyond the appearance, but in the distortion to bring it back to a recording of the appearance.

DS Are you saying that painting is almost a way of bringing somebody back, that the process of painting is almost like the process of recalling?

FB I am saying it. And I think that the methods by which this is done are so artificial that the model before you, in my case, inhibits the artificiality by which this thing can be brought back.

39 JOHN DEAKIN Photograph of Henrietta Moraes DS And what if someone you've already painted many times from memory and photographs sits for you?

FB They inhibit me. They inhibit me because, if I like them, I don't want to practise before them the injury that I do to them in my work. I would rather practise the injury in private by which I think I can record the fact of them more clearly.

DS In what sense do you conceive it as an injury?

FB Because people believe – simple people at least – that the distortions of them are an injury to them – no matter how much they feel for or how much they like you.

DS Don't you think their instinct is probably right?

FB Possibly, possibly. I absolutely understand this. But tell me, who today has been able to record anything that comes across to us as a fact without causing deep injury to the image?

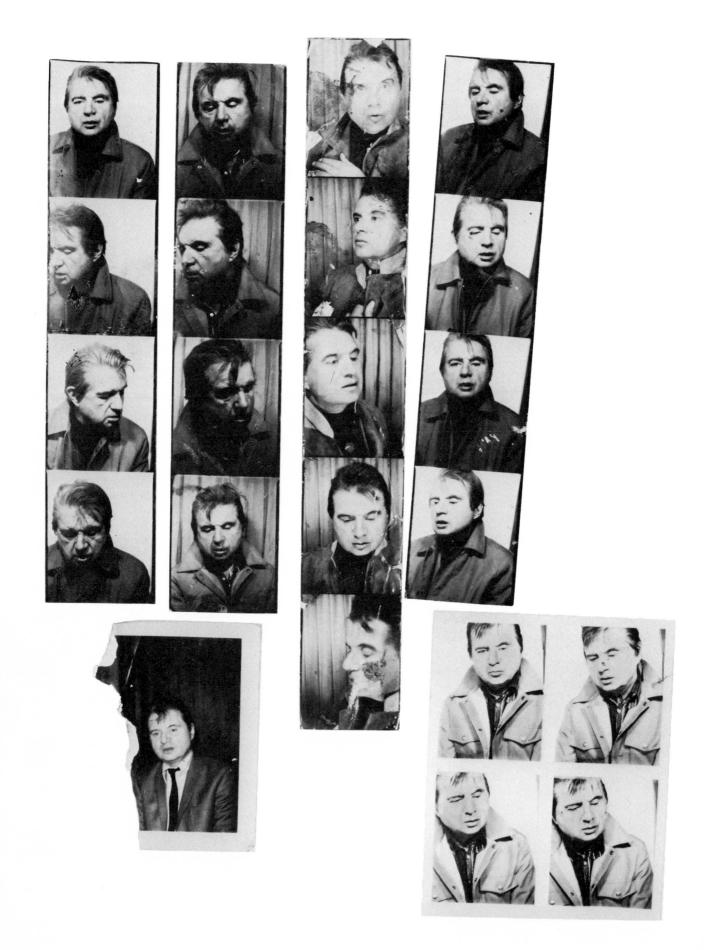

40 Photographs of Bacon taken by himself in automatic booths

DS But do you not think, since you talk about recording different levels of feeling in one image, that, among other things, you may be expressing at one and the same time a love of the person and a hostility towards them – that what you are making may be both a caress and an assault?

FB I think that is too logical. I don't think that's the way things work. I think it goes to a deeper thing: how do I feel I can make this image more immediately real to myself? That's all.

DS Would it not be making it more immediately real to objectify contradictory feelings towards the subject?

FB Well, I think that then you would be going into psychological ways of seeing, and I don't think that most painters do. Although it may be subconsciously involved with what you said, I don't think it is consciously involved at all.

DS Well, of course, if it were conscious it would be disastrous for the work. What I've been trying to suggest is that, when the sitter naïvely supposes that the painter is doing him an injury, he's instinctively recognizing an unconscious desire in the painter to inflict damage.

FB It may be. What you're really saying is what Wilde said: you kill the thing you love. It may be that; I don't know. Whether the distortions which I think sometimes bring the image over more violently are damage is a very questionable idea. I don't think it is damage. You may say it's damaging if you take it on the level of illustration. But not if you take it on the level of what I think of as art. One brings the sensation and the feeling of life over the only way one can. I don't say it's a good way, but one brings it over at the most acute point one can. $\Box \Box \Box$

DS Is it a part of your intention to try and create a tragic art?

FB No. Of course, I think that, if one could find a valid myth today where there was the distance between grandeur and its fall of the tragedies of Aeschylus and Shakespeare, it would be tremendously helpful. But when you're outside a tradition, as every artist is today, one can only want to record one's own feelings about certain situations as closely to one's own nervous system as one possibly can. But in

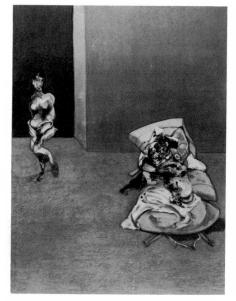

41 Crucifixion 196543 (Opposite) Centre panel of 41

42 Fragment of a Crucifixion 1950

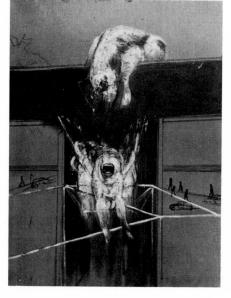

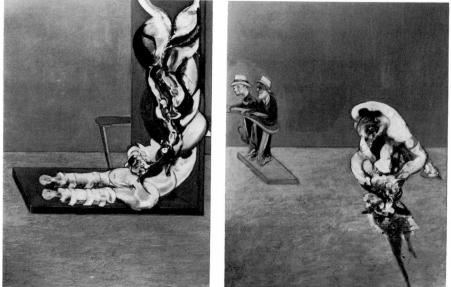

recording these things I may be one of those people who want the distances between what used to be called poverty and riches or between power and the opposite of power.

DS There is, of course, one great traditional mythological and tragic subject you've painted very often, which is the Crucifixion.

FB Well, there have been so very many great pictures in European art of the Crucifixion that it's a magnificent armature on which you can hang all types of feeling and sensation. You may say it's a curious thing for a non-religious person to take the Crucifixion, but I don't think that that has anything to do with it. The great Crucifixions that one knows of – one doesn't know whether they were painted by men who had religious beliefs.

DS But they were painted as part of Christian culture and they were made for believers.

FB Yes, that is true. It may be unsatisfactory, but I haven't found another subject so far that has been as helpful for covering certain areas of human feeling and behaviour. Perhaps it is only because so many people have worked on this particular theme that it has created this armature -I can't think of a better way of saying it - on which one can operate all types of level of feeling.

DS Of course, a lot of modern artists in all the media faced with this problem have gone back to the Greek myths. You yourself, in the *Three Studies for Figures at the Base of a*

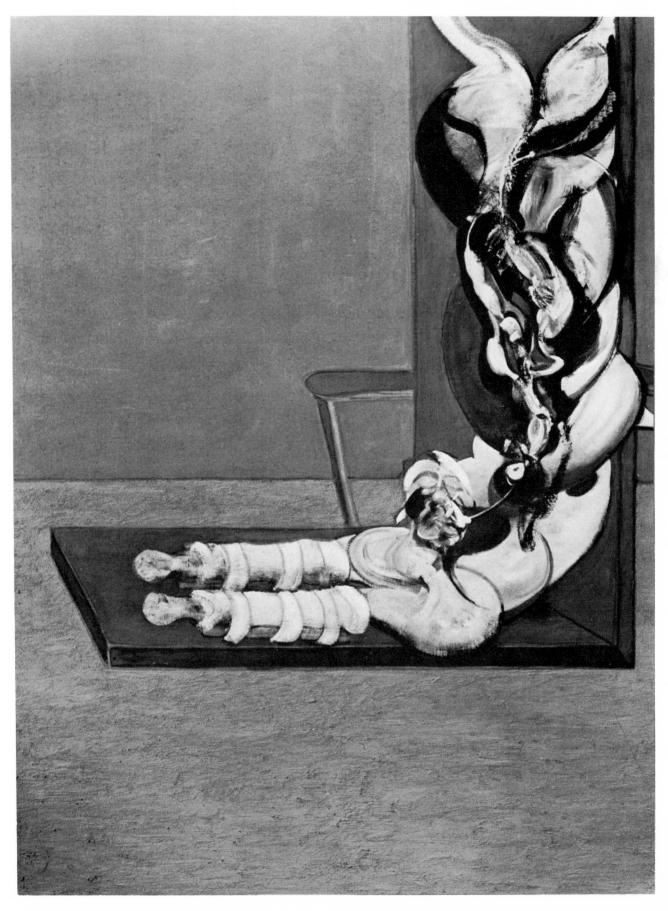

Crucifixion (4), didn't paint the traditional Christian figures at the foot of the Cross, but the Eumenides. Are there other themes from Greek mythology that you've ever thought of using?

FB Well, I think Greek mythology is even further from us than Christianity. One of the things about the Crucifixion is the very fact that the central figure of Christ is raised into a very pronounced and isolated position, which gives it, from a formal point of view, greater possibilities than having all the different figures placed on the same level. The alteration of level is, from my point of view, very important.

DS In painting a Crucifixion, do you find you approach the problem in a radically different way from when working on other paintings?

FB Well, of course, you're working then about your own feelings and sensations, really. You might say it's almost nearer to a self-portrait. You are working on all sorts of very private feelings about behaviour and about the way life is.

DS One very personal recurrent configuration in your work is the interlocking of Crucifixion imagery with that of the butcher's shop. The connexion with meat must mean a great deal to you.

FB Well, it does. If you go to some of those great stores, where you just go through those great halls of death, you can see meat and fish and birds and everything else all lying dead there. And, of course, one has got to remember as a painter that there is this great beauty of the colour of meat.

DS The conjunction of the meat with the Crucifixion seems to happen in two ways – through the presence on the scene of sides of meat and through the transformation of the crucified figure itself into a hanging carcass of meat.

FB Well, of course, we are meat, we are potential carcasses. If I go into a butcher's shop I always think it's surprising that I wasn't there instead of the animal. But using the meat in that particular way is possibly like the way one might use the spine, because we are constantly seeing images of the human body through X-ray photographs and that obviously does alter the ways by which one can use the body. You must know the beautiful Degas pastel in the National Gallery of a woman sponging her back. And you will find at the very top of the spine that the spine almost comes out of

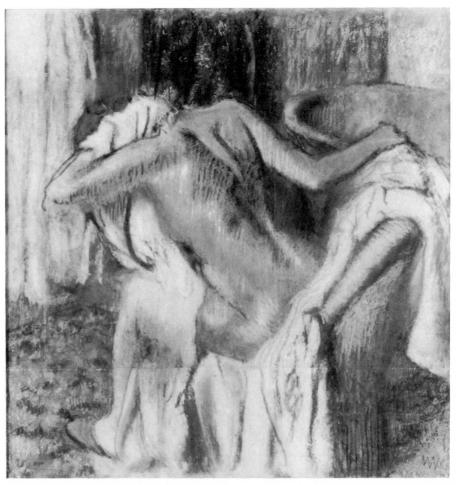

44 DEGAS After the Bath 1903

the skin altogether. And this gives it such a grip and a twist that you're more conscious of the vulnerability of the rest of the body than if he had drawn the spine naturally up to the neck. He breaks it so that this thing seems to protrude from the flesh. Now, whether Degas did this purposely or not, it makes it a much greater picture, because you're suddenly conscious of the spine as well as the flesh, which he usually just painted covering the bones. In my case, these things have certainly been influenced by X-ray photographs.

DS It's clear that much of your obsession with painting meat has to do with matters of form and colour – it's clear from the works themselves. Yet the Crucifixion paintings have surely been among those which have made critics emphasize what they call the element of horror in your work.

FB Well, they certainly have always emphasized the horror side of it. But I don't feel this particularly in my work. I have never tried to be horrific. One only has to have observed things and know the undercurrents to realize that anything that I have been able to do hasn't stressed that side of life. When you go into a butcher's shop and see how beautiful meat can be and then you think about it, you can think of the whole horror of life – of one thing living off another. It's like all those stupid things that are said about bull-fighting. Because people will eat meat and then complain about bullfighting; they will go in and complain about bull-fighting covered with furs and with birds in their hair.

DS It seems to be quite widely felt of the paintings of men alone in rooms that there's a sense of claustrophobia and unease about them that's rather horrific. Are you aware of that unease?

FB I'm not aware of it. But most of those pictures were done of somebody who was always in a state of unease, and whether that has been conveyed through these pictures I don't know. But I suppose, in attempting to trap this image, that, as this man was very neurotic and almost hysterical, this may possibly have come across in the paintings. I've always hoped to put over things as directly and rawly as I possibly can, and perhaps, if a thing comes across directly, people feel that that is horrific. Because, if you say something very directly to somebody, they're sometimes offended, although it is a fact. Because people tend to be offended by facts, or what used to be called truth.

DS On the other hand, it's not altogether stupid to attribute an obsession with horror to an artist who has done so many paintings of the human scream.

FB You could say that a scream is a horrific image; in fact, I wanted to paint the scream more than the horror. I think, if I had really thought about what causes somebody to scream, it would have made the scream that I tried to paint more successful. Because I should in a sense have been more conscious of the horror that produced the scream. In fact they were too abstract.

DS They were too purely visual?

FB I think so. Yes.

DS The open mouths - are they always meant to be a scream?

FB Most of them, but not all. You know how the mouth changes shape. I've always been very moved by the movements of the mouth and the shape of the mouth and the teeth. People say that these have all sorts of sexual implications, and I was always very obsessed by the actual appearance of

45 (Opposite) Study for Figure IV 1956–7

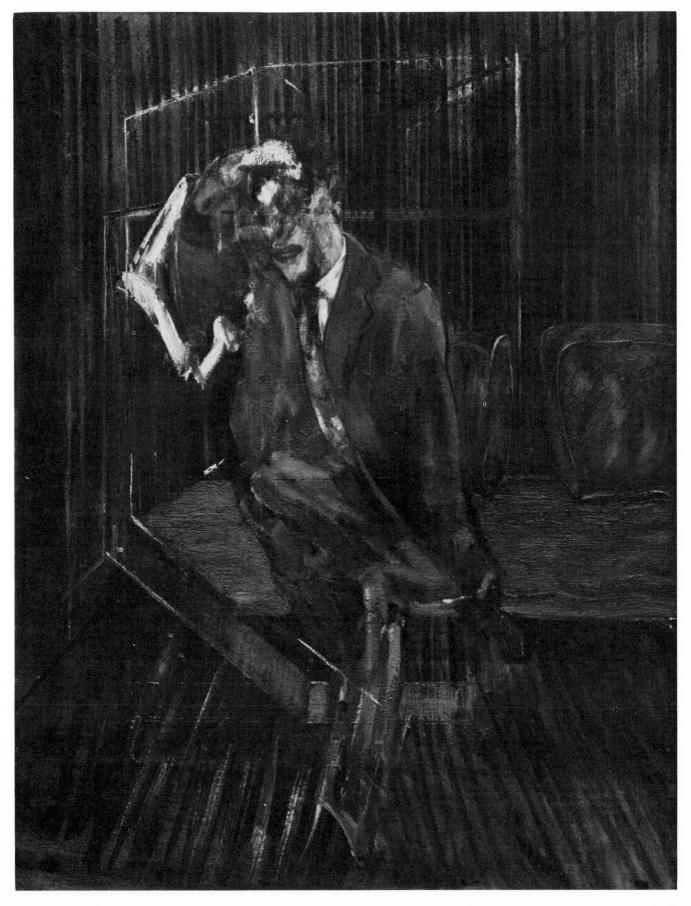

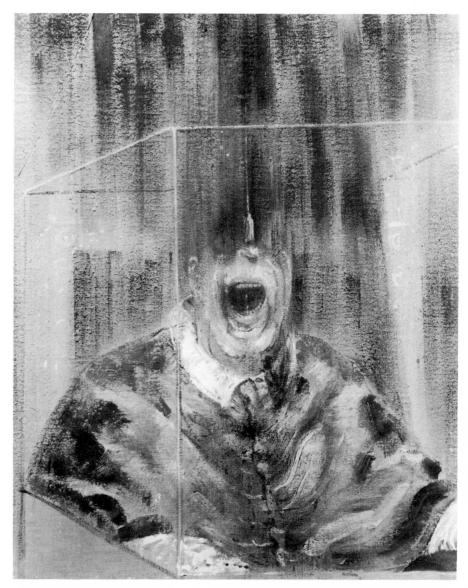

46 Head VI 1949

the mouth and teeth, and perhaps I have lost that obsession now, but it was a very strong thing at one time. I like, you may say, the glitter and colour that comes from the mouth, and I've always hoped in a sense to be able to paint the mouth like Monet painted a sunset.

DS So you might well have been interested in painting open mouths and teeth even if you hadn't been painting the scream?

FB I think I might. And I've always wanted and never succeeded in painting the smile. \Box \Box

DS You once wrote of painting as being a game of chance. When you go gaming, you play roulette rather than chemmy? FB Well, generally, yes.

DS Because you like the impersonality of it?

I like the impersonality. I hate the personality that FBchemmy players put on between one another, and so I like the completely impersonal thing of roulette. Also it just happens that I have been luckier at roulette than I have at chemmy. I feel that now my luck has completely deserted me as a gambler, for the present time. Luck's a funny thing; it runs in long patches, and sometimes one runs into a long patch of very good luck. When I was never able to earn any money from my work, I was able sometimes in casinos to make money which altered my life for a time, and I was able to live on it and live in a way that I would never have been able to if I had been earning it. But now I seem to have run out of that patch. I remember when I lived once for a long time in Monte Carlo and I became very obsessed by the casino and I spent whole days there – and there you could go in at ten o'clock in the morning and needn't come out until about four o'clock the following morning – and at that time, which was a good many years ago, I had very little money, and I did sometimes have very lucky wins. I used to think that I heard the croupier calling out the winning number at roulette before the ball had fallen into the socket, and I used to go from table to table. And I remember one afternoon I went in there, and I was playing on three different tables, and I heard these echoes. And I was playing rather small stakes, but at the end of that afternoon chance had been very much on my side and I ended up with about sixteen hundred pounds, which was a lot of money for me then. Well, I immediately took a villa, and I stocked it with drink and all the food that I could buy in, but this chance didn't last very long, because in about ten days' time I could hardly buy my fare back to London from Monte Carlo. But it was a marvellous ten days and I had an enormous number of friends.

DS It's often said that people gamble in order to lose, and I feel that my own gambling was done in order to lose. Does this apply in your case or do you feel you actually want to win?

FB I feel I want to win, but then I feel exactly the same thing in painting. I feel I want to win even if I always lose.

DS When you have a good win, which means more to you: the feeling that the gods are on your side – to use a phrase

you've used about chance in painting – or the advantages you get out of it in good living?

FB I think the advantages I can get out of it.

DS You like to live well?

FB I live in, you may say, a gilded squalor. I would hate always to what is called live in luxurious places. But I like, when I want to, to be able to go to them and to live that kind of life.

DS What is it you like about, say, staying in good hotels?

FB I like comfort and I like being able to have service easily laid on. I don't live at all that way myself, as you know. But I terribly like, when I go to those places, for it to be very easy to get things done for you that you want, that money buys for you.

DS Is it the easiness of it or the idea of luxury itself that attracts you?

FB I think it's the ease. But then, if we go on to luxury, luxury obviously alters people. I mean, one knows that people who can live in luxury and do everything they want generally become desperately bored. And they plan all sorts of little devices and expeditions by which to relieve their boredom. I remember once in the Ritz going up with a rich man who happened to be in the lift, and he'd been in Soho shopping to buy some peas and new potatoes, and the bag burst, and it all fell on the floor of the lift presumably taking him up to his room where I imagine he had a little oil stove where he was able to cook the peas and potatoes. Well, that is luxury for a rich man.

DS Quite. You were saying that for the moment you've exhausted your luck as a gambler. What about luck in your work?

FB I think that accident, which I would call luck, is one of the most important and fertile aspects of it, because, if anything works for me, I feel it is nothing I have made myself, but something which chance has been able to give me. But it's true to say that over a great many years I have been thinking about chance and about the possibilities of using what chance can give, and I never know how much it is pure chance and how much it is manipulation of it.

DS You probably find that you get better at manipulating it.

FB One possibly gets better at manipulating the marks that have been made by chance, which are the marks that one made quite outside reason. As one conditions oneself by time and by working to what happens, one becomes more alive to what the accident has proposed for one. And, in my case, I feel that anything I've ever liked at all has been the result of an accident on which I have been able to work. Because it has given me a disorientated vision of a fact I was attempting to trap. And I could then begin to elaborate, and try and make something out of a thing which was nonillustrational.

DS I can think of three ways in which an accident might happen. One would be when you were exasperated with what you had done and either with a cloth or with a brush freely scrubbed over it. A second would be when you painted impatiently and made marks across the form in annoyance. A third might be when you painted absent-mindedly, when your attention was wandering.

FB Or when you were drunk. Well, of course, all three, or all four, may work; they may or may not. They generally don't, of course.

DS In what other ways would an accident happen, or are those more or less the sorts of ways?

FB I would say that those were the ways. But I think that you can make, very much as in abstract painting, involuntary marks on the canvas which may suggest much deeper ways by which you can trap the fact you are obsessed by. If anything ever does work in my case, it works from that moment

47 Three Studies for Portrait of Lucian Freud 1965

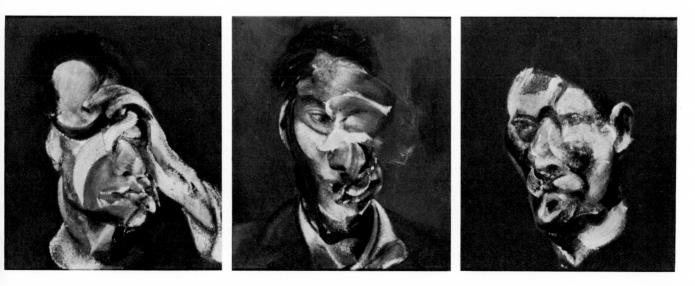

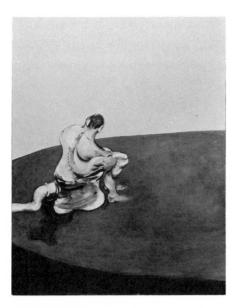

48 Three Figures in a Room 1964

when consciously I don't know what I'm doing. I've often found that, if I have tried to follow the image more exactly, in the sense of its being more illustrational, and it has become extremely banal, and then out of sheer exasperation and hopelessness I've completely destroyed it by not knowing at all the marks I was making within the image – suddenly I have found that the thing comes nearer to the way that my visual instincts feel about the image I am trying to trap. It's really a question in my case of being able to set a trap with which one would be able to catch the fact at its most living point.

DS What are you thinking about at the time? How do you suspend the operation of conscious decision?

FB At that moment I'm thinking of nothing but how hopeless and impossible this thing is to achieve. And by making these marks without knowing how they will behave, suddenly there comes something which your instinct seizes on as being for a moment the thing which you could begin to develop.

DS How much does it help to drink when you're painting?

FB This is a difficult thing to say. I haven't done many things when I have had a lot to drink but I have done one or two. I did the *Crucifixion* in 1962 (8) when I was on drink for about a fortnight. Sometimes it loosens you, but again I think it also dulls other areas. It leaves you freer, but on the other hand it dulls your final judgement of what you hold. I don't actually believe that drink and drugs help me. They may help other people, but they don't really help me.

49 (Opposite) Right-hand panel of 48

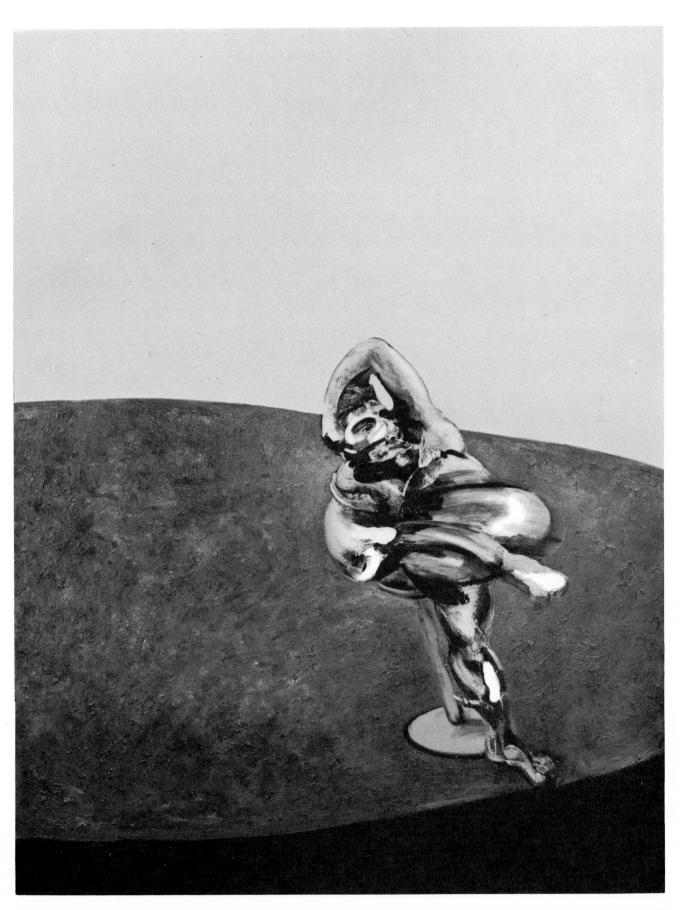

DS In other words, although you talk about the importance of chance, you really don't want to lose a certain clarity. You don't want to leave too much to chance, do you?

FB I want a very ordered image but I want it to come about by chance.

DS But you're sufficiently puritanical not to want to make the chance come too easily.

FB I would like things to come easily, but you can't order chance. This is the thing. Because if you could, you would only be imposing another type of illustration.

DS Are you aware of the moment when you find that you are becoming free and the thing is taking you over?

FB Well, very often the involuntary marks are much more deeply suggestive than others, and those are the moments when you feel that anything can happen.

DS You feel it while you're making those marks?

FB No, the marks are made, and you survey the thing like you would a sort of graph. And you see within this graph the possibilities of all types of fact being planted. This is a difficult thing; I'm expressing it badly. But you see, for instance, if you think of a portrait, you maybe at one time have put the mouth somewhere, but you suddenly see through this graph that the mouth could go right across the face. And in a way you would love to be able in a portrait to make a Sahara of the appearance – to make it so like, yet seeming to have the distances of the Sahara.

DS It's a matter of reconciling opposites, I suppose – of making the thing be contradictory things at once.

FB Isn't it that one wants a thing to be as factual as possible and at the same time as deeply suggestive or deeply unlocking of areas of sensation other than simple illustration of the object that you set out to do? Isn't that what all art is about?

DS Could you try and define the difference between an illustrational and a non-illustrational form?

FB Well, I think that the difference is that an illustrational form tells you through the intelligence immediately what the form is about, whereas a non-illustrational form works first upon sensation and then slowly leaks back into the fact. Now why this should be, we don't know. This may have to do

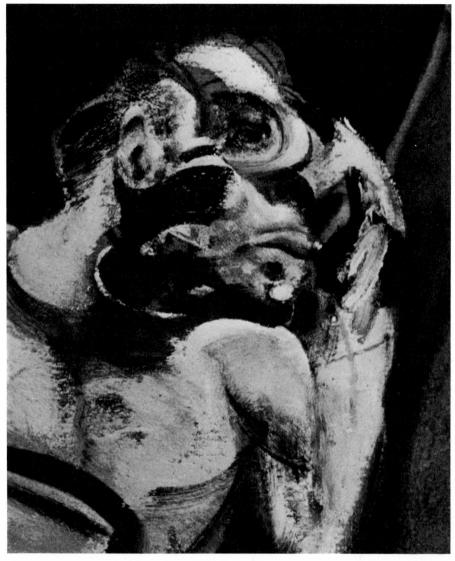

50 Detail from centre panel of 48

with how facts themselves are ambiguous, how appearances are ambiguous, and therefore this way of recording form is nearer to the fact by its ambiguity of recording.

DS When you get a photograph taken with a high-speed camera that produces an entirely unexpected effect which is highly ambiguous and exciting, because the image is the thing and it isn't, or because it's surprising that this shape is the thing: now, is that illustration?

FB I think it is. I think it is a diverted illustration. I think the difference from direct recording through the camera is that as an artist you have to, in a sense, set a trap by which you hope to trap this living fact alive. How well can you set the trap? Where and at what moment will it click? And there's another thing, that has to do with texture. I think the texture of a painting seems to be more immediate than the texture of a photograph, because the texture of a photo graph seems to go through an illustrational process onto the nervous system, whereas the texture of a painting seems to come immediately onto the nervous system. It's terribly like for instance... Supposing you were to think of great ancient Egyptian things made of bubble gum, supposing you were to think of the Sphinx made of bubble gum, would it have had the same effect upon the sensibility over the centuries i. you could pick it up gently and lift it?

DS You're giving this as an example of the effect of a great work's depending on the mysterious way in which the image combines with the material that it's made of?

FB I think it has to do with endurance. I think that you could have a marvellous image made of something which wil disappear in a few hours, but I think that the potency of the image is created partly by the possibility of its enduring And, of course, images accumulate sensation around them selves the longer they endure.

DS The thing that's difficult to understand is how it is that marks of the brush and the movement of paint on canvas can speak so directly to us.

 \mathbf{FB} Well, if you think of the great Rembrandt self-portrait in Aix-en-Provence, for instance, and if you analyze it, you will see that there are hardly any sockets to the eyes, that it is almost completely anti-illustrational. I think that the mystery of fact is conveyed by an image being made out of non-rational marks. And you can't will this non-rationality of a mark. That is the reason that accident always has to enter into this activity, because the moment you know what to do, you're making just another form of illustration. But what can happen sometimes, as it happened in this Rembrand self-portrait, is that there is a coagulation of non-representa tional marks which have led to making up this very great image. Well, of course, only part of this is accidental. Behind all that is Rembrandt's profound sensibility, which was able to hold onto one irrational mark rather than onto another And abstract expressionism has all been done in Rembrandt's marks. But in Rembrandt it has been done with the added thing that it was an attempt to record a fact and to me there fore must be much more exciting and much more profound. One of the reasons why I don't like abstract painting, or why it doesn't interest me, is that I think painting is a duality,

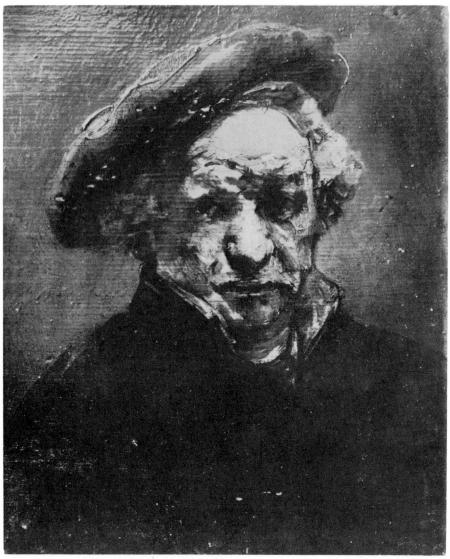

51 REMBRANDT Self-Portrait c. 1659. The authenticity of this picture has recently been questioned by certain scholars

> and that abstract painting is an entirely aesthetic thing. It always remains on one level. It is only really interested in the beauty of its patterns or its shapes. We know that most people, especially artists, have large areas of undisciplined emotion, and I think that abstract artists believe that in these marks that they're making they are catching all these sorts of emotions. But I think that, caught in that way, they are too weak to convey anything. I think that great art is deeply ordered. Even if within the order there may be enormously instinctive and accidental things, nevertheless I think that they come out of a desire for ordering and for returning fact onto the nervous system in a more violent way. Why, after the great artists, do people ever try to do anything again? Only because, from generation to generation, through what the great artists have done, the instincts change. And, as the instincts change, so there comes a

renewal of the feeling of how can I remake this thing once again more clearly, more exactly, more violently. You see, I believe that art is recording; I think it's reporting. And I think that in abstract art, as there's no report, there's nothing other than the aesthetic of the painter and his few sensations. There's never any tension in it.

DS You don't think it can convey feelings?

FB I think it can convey very watered-down lyrical feelings, because I think any shapes can. But I don't think it can really convey feeling in the grand sense.

DS By which you mean more specific and more directed feelings?

FB Yes.

DS You say it lacks tension, but don't you think that certain kinds of expectation which the spectator has of art can be disturbed by an abstract painting in a way that can engender tension?

FB I think it's possible that the onlooker can enter even more into an abstract painting. But then anybody can enter more into what is called an undisciplined emotion, because, after all, who loves a disastrous love affair or illness more than the spectator? He can enter into these things and feel he is participating and doing something about it. But that of course has nothing to do with what art is about. What you're talking about now is the entry of the spectator into the performance, and I think in abstract art perhaps they can enter more, because what they are offered is something weaker which they haven't got to combat.

DS If abstract paintings are no more than pattern-making, how do you explain the fact that there are people like myself who have the same sort of visceral response to them at times as they have to figurative works?

FB Fashion.

DS You really think that?

FB I think that only time tells about painting. No artist knows in his own lifetime whether what he does will be the slightest good, because I think it takes at least seventy-five to a hundred years before the thing begins to sort itself out from the theories that have been formed about it. And I think that most people enter a painting by the theory that

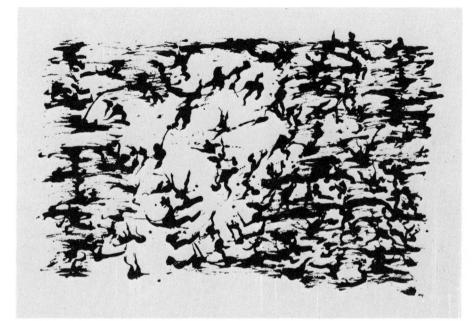

52 MICHAUX Untitled Indian ink drawing 1962

> has been formed about it and not by what it is. Fashion suggests that you should be moved by certain things and should not by others. This is the reason that even successful artists – and especially successful artists, you may say – have no idea whatever whether their work's any good or not, and will never know.

DS Not long ago you bought a picture . . .

FB By Michaux.

DS ... by Michaux, which was more or less abstract. I know you got tired of it in the end and sold it or gave it away, but what made you buy it?

FB Well, firstly, I don't think it's abstract. I think Michaux is a very, very intelligent and conscious man, who is aware of exactly the situation that he is in. And I think that he has made the best *tachiste* or free marks that have been made. I think he is much better in that way, in making free marks, than Jackson Pollock.

DS Can you say what gives you this feeling?

FB What gives me the feeling is that it is more factual; it suggests more. Because after all, this painting, and most of his paintings, have always been about delayed ways of remaking the human image, through a mark which is totally outside an illustrational mark but yet always conveys you back to the human image – a human image generally dragging and trudging through deep ploughed fields, or something like

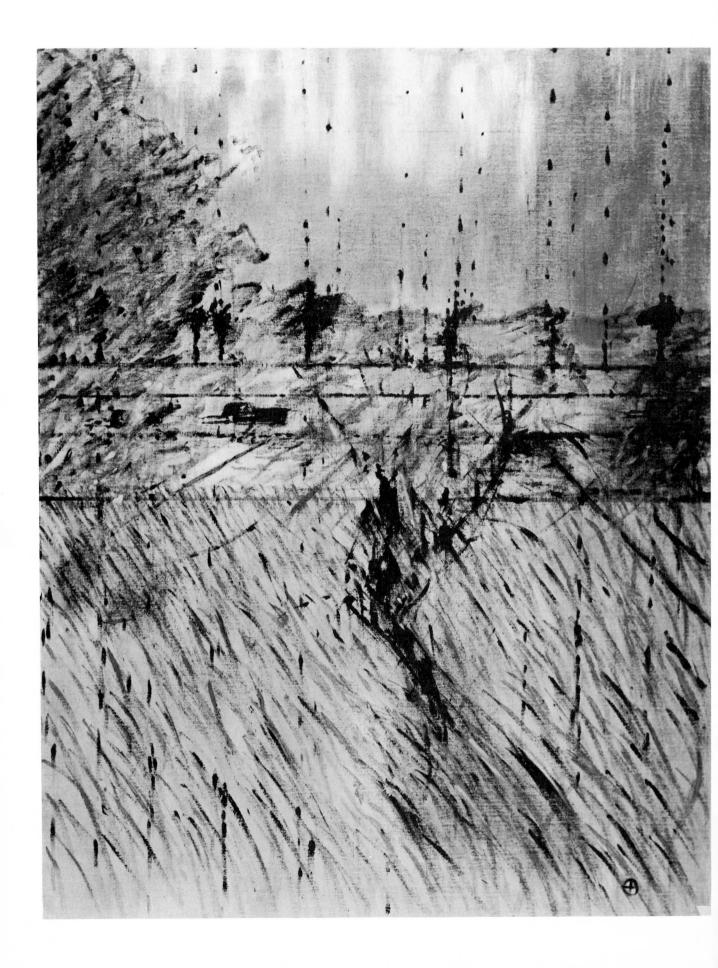

53 Landscape 1952

that. They are about these images moving and falling and so on.

DS Are you ever as moved by looking at a still life or a landscape by a great master as you are by looking at paintings of the human image? Does a Cézanne still life or landscape ever move you as much as a Cézanne portrait or nude?

FB No, it doesn't, although I think that Cézanne's landscapes are very much better than his figures, generally. I think that there are one or two figure-paintings which are marvellous, but generally speaking I think the landscapes are better.

DS Nevertheless, the figures say more to you?

FB They do, yes.

DS What is it that made you paint a number of landscapes at one time?

FB Inability to do the figure.

DS And did you feel that you weren't going to do land-scapes for long?

FB I don't know that I felt that at the time. After all, one is always hoping that one will be able to do something nearer one's instinctive desire. But certainly landscapes interest me much less. I think art is an obsession with life and after all, as we are human beings, our greatest obsession is with ourselves. Then possibly with animals, and then with landscapes.

DS You're really affirming the traditional hierarchy of subject matter by which history painting-painting of mythological and religious subjects – comes top and then portraits and then landscape and then still life.

FB I would alter them round. I would say at the moment, as things are so difficult, that portraits come first.

DS In fact, you've done very few paintings with several figures. Do you concentrate on the single figure because you find it more difficult?

FB I think that the moment a number of figures become involved, you immediately come on to the story-telling aspect of the relationships between figures. And that immediately sets up a kind of narrative. I always hope to be able to make a great number of figures without a narrative.

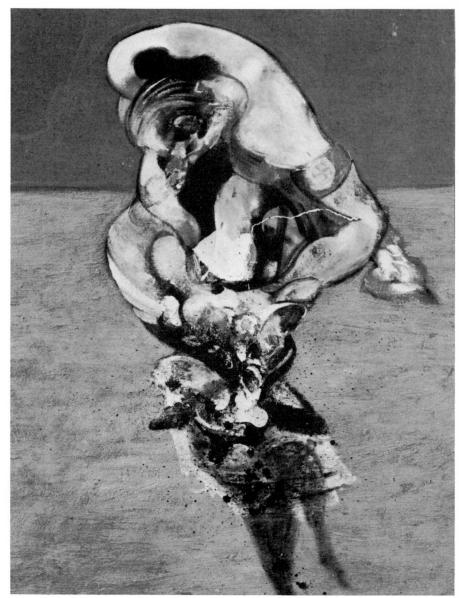

54 Detail from right-hand panel of 41

DS As Cézanne does in the bathers?

FB He does.

DS You painted a picture not long ago which people interpreted narratively: it was a Crucifixion triptych, and there was a figure on the right who wore an armband with a swastika. Now, some people thought that this was meant to be a Nazi, and some people thought that this was not a Nazi, but that it was like a character in Genet's play, *The Balcony*, who had dressed up as a Nazi. Well, this was an example of people making a narrative interpretation. I'd like to ask, firstly, whether either of those things was meant and, secondly, whether this was the kind of narrative interpretation that you dislike. FB Well I do dislike it. It was also, you may say, a stupid thing to put the swastika there. But I wanted to put an armband to break the continuity of the arm and to add the colour of this red round the arm. You may say it was a stupid thing to do, but it was done entirely as part of trying to make the figure work – not work on the level of interpretation of its being a Nazi, but on the level of its working formally.

DS Then why the swastika?

FB Because I was looking at that time at some coloured photographs that I had of Hitler standing with his entourage, and all of them had these bands round their arms with a swastika.

DS Now, when you painted this you must have known that people would see a narrative thing there, or didn't this occur to you?

FB I think it occurred to me, but I don't think I cared much about it.

DS And when people interpreted it narratively, did that irritate you?

FB Not especially. Because, if I was irritated about what people said about the things, I would be in continuous irritation. I don't think it was a successful thing to do - do you see what I mean? But it was the only thing I could do at that moment.

DS Why is it you want to avoid telling a story?

FB I don't want to avoid telling a story, but I want very, very much to do the thing that Valéry said – to give the sensation without the boredom of its conveyance. And the moment the story enters, the boredom comes upon you.

DS You think this necessarily happens or that you haven't been able to get outside it yet?

FB I think I haven't been able to get outside it. I don't know who today has.

DS Do you feel it is more difficult to paint now than it has been before?

FB I think it is more difficult because painters had a double role before. I think that they thought that they were recording, and then they did something very much more than

recording. I think that now, with the mechanical methods of recording there, such as the film and the camera and the tape recorder, you have to come down in painting to something more basic and fundamental. Because it can be done better by other means on what I think is a more superficial level -I'm not talking about film, which is cut and remade into all sorts of different things, but I'm thinking about the direct photograph and direct recording. I think that those have taken over the illustrational thing that painters in the past believed they had to do. And I think that abstract painters, realizing this, have thought: why not throw out all illustration and all forms of recording and just give the effects of form and colour? And logically this is quite right. But it hasn't worked out, because it seems that the obsession with something in life that you want to record gives a much greater tension and a much greater excitement than when you've simply said you'll just go on in a free-fancy way and record the shapes and the colours. I think we are in a very curious position today because, when there's no tradition at all, there are two extreme ends. There is direct reporting like something that's very near to a police report. And then there's only the attempt to make great art. And what is called the in-between art really, in a time like ours, doesn't exist. It doesn't mean that, in the attempt to make great art, anybody will ever do it in our time. But this is what creates an extreme situation, you may say. Because, with these marvellous mechanical means of recording fact, what can you do but go to a very much more extreme thing where you are reporting fact not as simple fact but on many levels, where you unlock the areas of feeling which lead to a deeper sense of the reality of the image, where you attempt to make the construction by which this thing will be caught raw and alive and left there and, you may say, finally fossilized there it is.

DS Talking about the situation in the way you do points, of course, to the very isolated position in which you're working. The isolation is obviously a great challenge, but do you also find it a frustration? Would you rather be one of a number of artists working in a similar direction?

FB I think it would be more exciting to be one of a number of artists working together, and to be able to exchange... I think it would be terribly nice to have someone to talk to. Today there is absolutely nobody to talk to. Perhaps I'm unlucky and don't know those people. Those I know always have very different attitudes to what I have. But I think that artists can in fact help one another. They can clarify the situation to one another. I've always thought of friendship as where two people really tear one another apart and perhaps in that way learn something from one another.

DS Have you ever got anything from what's called destructive criticism made by critics?

FB I think that destructive criticism, especially by other artists, is certainly the most helpful criticism. Even if, when you analyze it, you may feel that it's wrong, at least you analyze it and think about it. When people praise you, well, it's very pleasant to be praised, but it doesn't actually help you.

DS Do you find you can bring yourself to make destructive criticism of your friends' work?

FB Unfortunately, with most of them I can't if I want to keep them as friends.

DS Do you find you can criticize their personalities and keep them as friends?

FB It's easier, because people are less vain of their personalities than they are of their work. They feel in an odd way, I think, that they're not irrevocably committed to their personality, that they can work on it and change it, whereas the work that has gone out – nothing can be done about it. But I've always hoped to find another painter I could really talk to – somebody whose qualities and sensibility I'd really believe in - who really tore my things to bits and whose judgement I could actually believe in. I envy very much, for instance, going to another art, I envy very much the situation when Eliot and Pound and Yeats were all working together. And in fact Pound made a kind of caesarean operation on The Waste Land; he also had a very strong influence on Yeats – although both of them may have been very much better poets than Pound. I think it would be marvellous to have somebody who would say to you, 'Do this, do that, don't do this, don't do that!' and give you the reasons. I think it would be very helpful.

DS You feel you really could use that kind of help?

FB I could. Very much. Yes. I long for people to tell me what to do, to tell me where I go wrong. $\Box \Box \Box$

DS You didn't start painting full-time till quite late.

FB I couldn't. When I was young, I didn't, in a sense, have a real subject. It's through my life and knowing other people that a subject has really grown. Also, perhaps it delayed me, never going to any art school or anything like that, although in many ways I think that could have been an advantage – I don't think art schools can do anything for artists today. But there are certain things I regret very much – for instance, not learning ancient Greek – but of course it's very much later that I regret it.

DS When do you think painting became central in your life?

FB I think it became central, really, from around 1945. As you know, through asthma and everything else, I was turned down from going into the army. And I think in those years Eric Hall had a great influence on me and encouraged me. But then he had a great influence altogether on my life, as he was an intelligent man and had a lot of sensibility. I mean, he taught me the value of things – for instance, what decent food was – that I certainly didn't learn in Ireland; the thing I appreciate from Ireland is the kind of freedom of life.

DS When you started designing furniture and rugs in the late 1920s, you were immediately doing work that was exceptional; and it was thought to be so at the time.

FB Yes, but it was just taken from other people, most of it. It was awfully influenced by French design of that time. I don't think anything was very original.

DS And you had no interest in going on and trying to do something more original?

55 (Opposite) Furniture and rugs designed by Bacon, photographed in his studio 1930

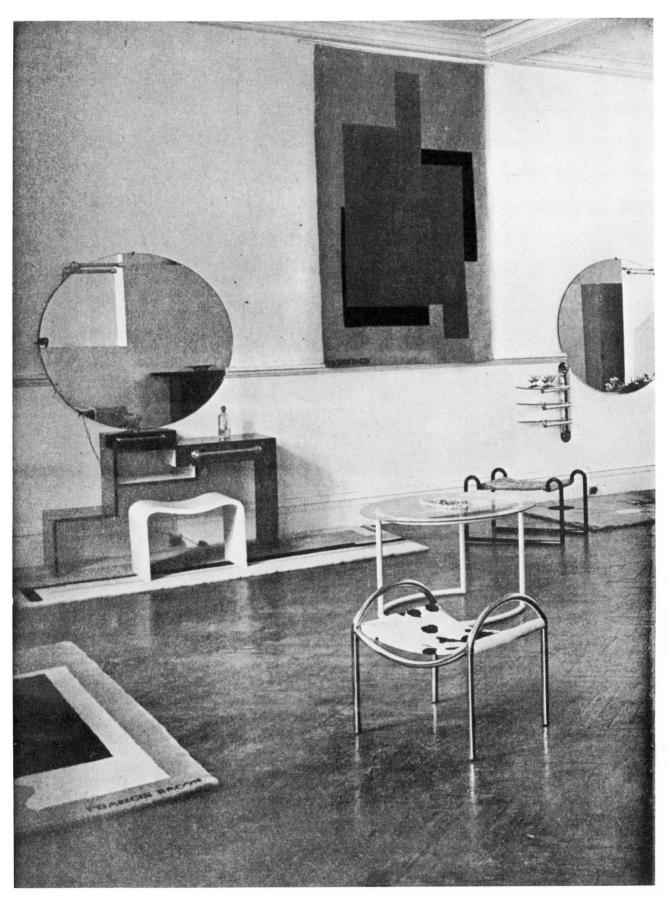

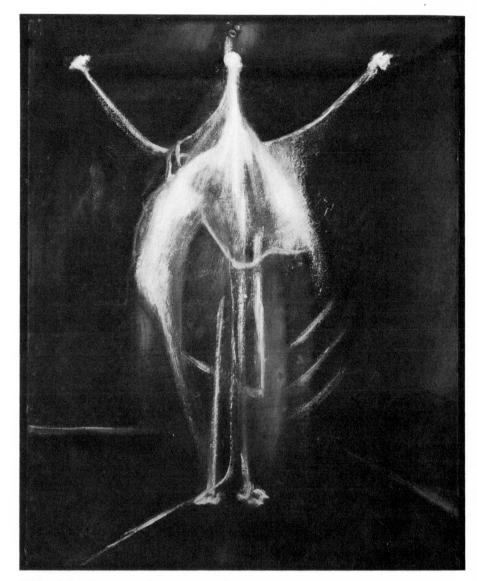

56 Crucifixion 1933

FB No. I started to try and do painting.

DS But there again, it didn't take long before you were doing exceptional work, like the *Crucifixion* which Herbert Read reproduced in *Art Now* in 1933. Nevertheless, you didn't paint a great deal in the following years, did you?

FB No, I didn't. I enjoyed myself.

DS But did you realize painting was going to become ...?

FB Not till much later, no. I regret now that I was such a late starter – I seem to have been a late starter in everything. I think I was kind of delayed, and I think there are those people who are delayed.

DS You talk of delay though you did remarkable work as a designer and as a painter in your early twenties.

FB I think the analytic side of my brain didn't develop till comparatively late – till I was about twenty-seven or twentyeight. When I was very young, you see, I was incredibly shy, and later I thought it was ridiculous to be shy, so I tried deliberately to get over this because I think old shy people are ridiculous. And when I was thirty or so I gradually began to be able to open myself out. But most people do it at a much younger age. So I always feel I wasted so many years of my life.

DS When you say you didn't have a subject, are you saying it from hindsight or were you aware of it at the time?

FB No, I say it through hindsight. But I always thought of those paintings from Velasquez as a failure, and that was perhaps one of the first subjects that I had. I became obsessed by this painting and I bought photograph after photograph of it. I think really that was my first subject.

DS And that began in the late 1940s. Do you think your involvement in it had something to do with feelings about your father?

FB I'm not quite sure I understand what you're saying.

DS Well, the Pope is *il Papa*.

 \mathbf{FB} Well, I certainly have never thought of it in that way, but I don't know – it's difficult to know what forms obsessions. The thing is, I never got on with either my mother or my father. They didn't want me to be a painter, they thought I was just a drifter, especially my mother. It was only when she began to realize that I was making some money out of it - and that was very late in her life and not so long before she died – that we made any contact and she altered her attitude; also my father had died and she had remarried twice and had changed a great deal. My father was very narrow-minded. He was an intelligent man who never developed his intellect at all. As you know, he was a trainer of racehorses. And he just fought with people. He really had no friends at all, because he fought with everybody, because he had this very opinionated attitude. And he certainly didn't get on with his children. I think he liked my youngest brother, who died when he was about fourteen. He certainly didn't get on with me.

DS And what were your feelings towards him?

FB Well, I disliked him, but I was sexually attracted to him

when I was young. When I first sensed it, I hardly knew it was sexual. It was only later, through the grooms and the people in the stables I had affairs with, that I realized that it was a sexual thing towards my father.

DS So perhaps the obsession with the Velasquez Pope had a strong personal meaning?

FB Well it's one of the most beautiful pictures in the world and I think I'm not at all exceptional as a painter in being obsessed by it. I think a number of artists have recognized it as being something very remarkable.

DS I don't think other painters have continued to make versions of it over and over again.

FB I wish I hadn't.

DS Of course, you often combined the Pope theme with another theme that you'd started using earlier – actually, I'd have expected you to say that either this or the Crucifixion was your first subject – the open mouth, the scream.

FB When I made the Pope screaming, I didn't do it in the way I wanted to. I was always, as I've said to you before, very obsessed by Monet, and I think I was obsessed by Monet even at a time when people weren't, because I remember that, when I said things about him, people said 'Oh, they're just a lot of ice-creams', and they couldn't see. Before that, I'd bought that very beautiful hand-coloured book on diseases of the mouth, and, when I made the Pope screaming, I didn't want to do it in the way that I did it – I wanted to make the mouth, with the beauty of its colour and everything, look like one of the sunsets or something of Monet, and not just the screaming Pope. If I did it again, which I hope to God I never will, I would make it like a Monet.

DS And not the black cavern which in fact....

FB Yes, not the black cavern.

DS I suppose the most crucial step in the development of your subject-matter came in the early 1950s when you started to do paintings of particular people you knew, whereas previously you'd mainly been doing variations on existing images. And you did them sometimes working from memory and sometimes from snapshots and quite often at first from the model. Was it a technical problem or a psychological one that had prevented you from doing that earlier?

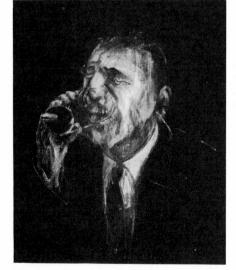

57 Man Drinking (Portrait of David Sylvester) 1955

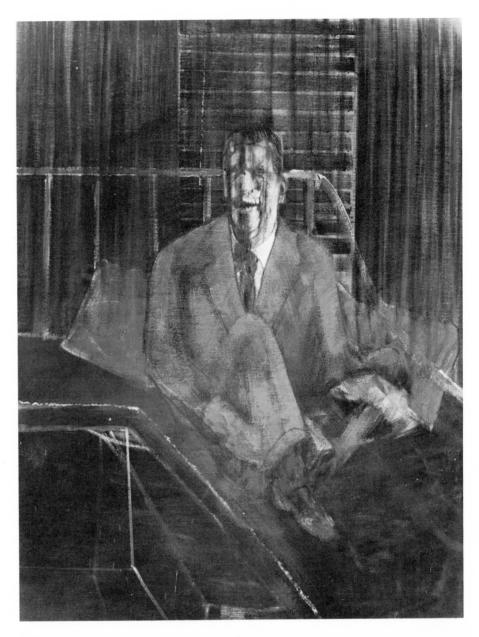

58 Study for a Portrait 1953

FB I think a technical problem.

DS It was easier to work from existing images than from a person or the memory of a person?

FB Yes.

DS Of course, in painting particular persons you've worked a lot from photographs of them.

FB Yes, but they're always people I've known very well, and the photographs are only used to make me remember their features, to revise my memory of them, as one would use a dictionary, really. I couldn't do people I didn't know very well. I wouldn't want to. It wouldn't interest me to try and do them unless I had seen a lot of them, watched their contours, watched the way they behaved.

DS In the same period as you were starting to paint particular people, you also did your first two paintings of figures coupled – the ones on a bed in 1953 and the ones in a field in 1954. And then it was about twelve years before you did more paintings of this theme, but since you started again it's been almost your dominant subject.

FB Well, of course, it's an endless subject, isn't it? You need never have any other subject, really. It's a very haunting subject, and I should be able to do it in a quite different way now – in the way I was going to do it when I had the idea of doing sculptures. Whether I will ever do them or

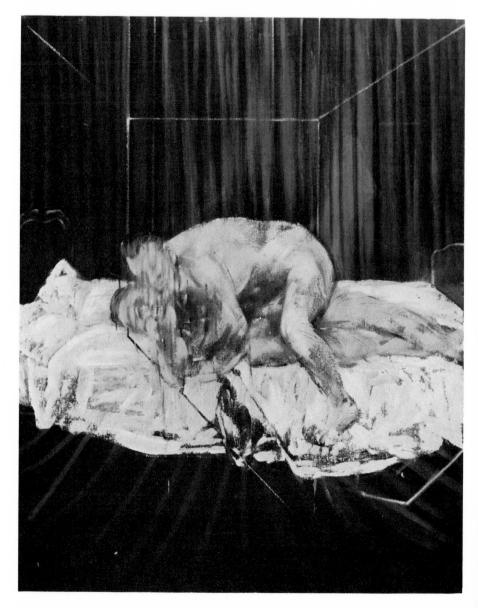

59 Two Figures 1953

60 (Opposite) Two Figures in the Grass 1954

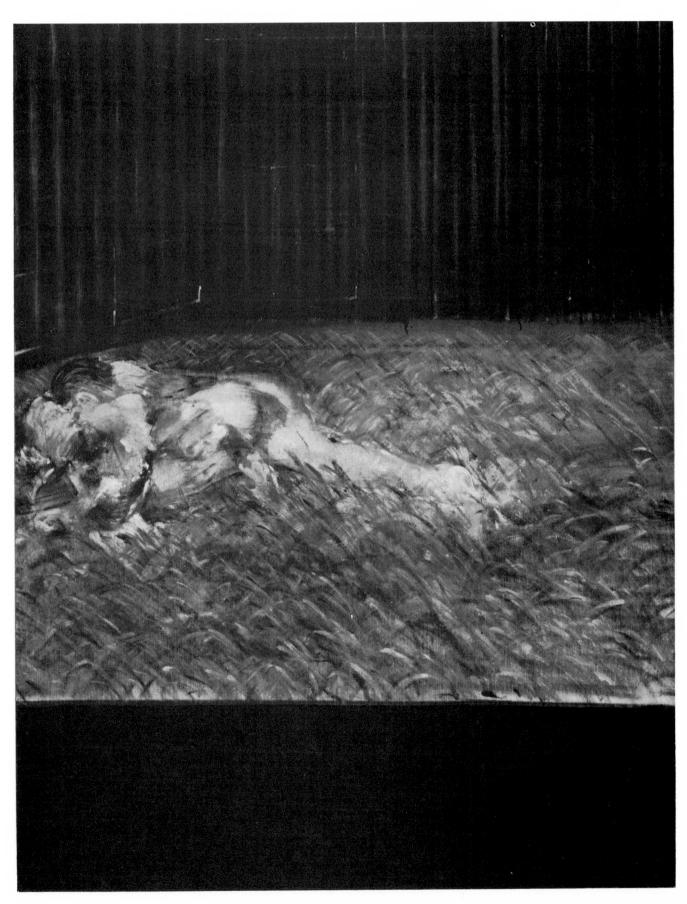

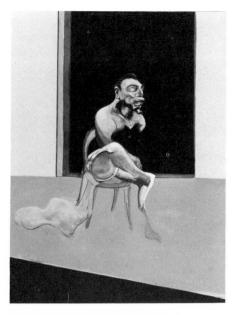

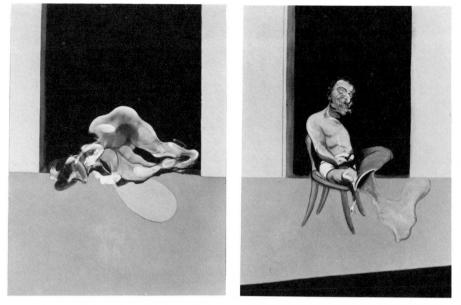

61 Triptych – August 1972

not is a different story, but I think I would be able to do the figures in a really different way by painting them as a transposition of how I was going to do them in the sculptures. I wasn't only going to do those kinds of figures in the sculptures, but also all sorts of things of the human body, and I can see that I can start in another way altogether now, now that I feel exorcized – although one's never exorcized. because people say you forget about death, but you don't. After all, I've had a very unfortunate life, because all the people I've been really fond of have died. And you don't stop thinking about them; time doesn't heal. But you concentrate on something which was an obsession, and what you would have put into your obsession with the physical act you put into your work. Because one of the terrible things about so-called love, certainly for an artist, I think, is the destruction. But I think without it they could probably never have.... I absolutely don't know. I was talking to somebody the other day and I said: 'Supposing one had just lived in a cottage somewhere and had had no experiences at all, all one's life, would one perhaps do exactly the same thing or better?' I think not, but I sometimes do wonder.

DS One thing that's always struck me about you is that, when you're talking about people you know, you tend to analyze how they've behaved or would be likely to behave in an extreme situation, and to judge them in that light. Are you aware you do that?

62 (Opposite) Centre panel of 61

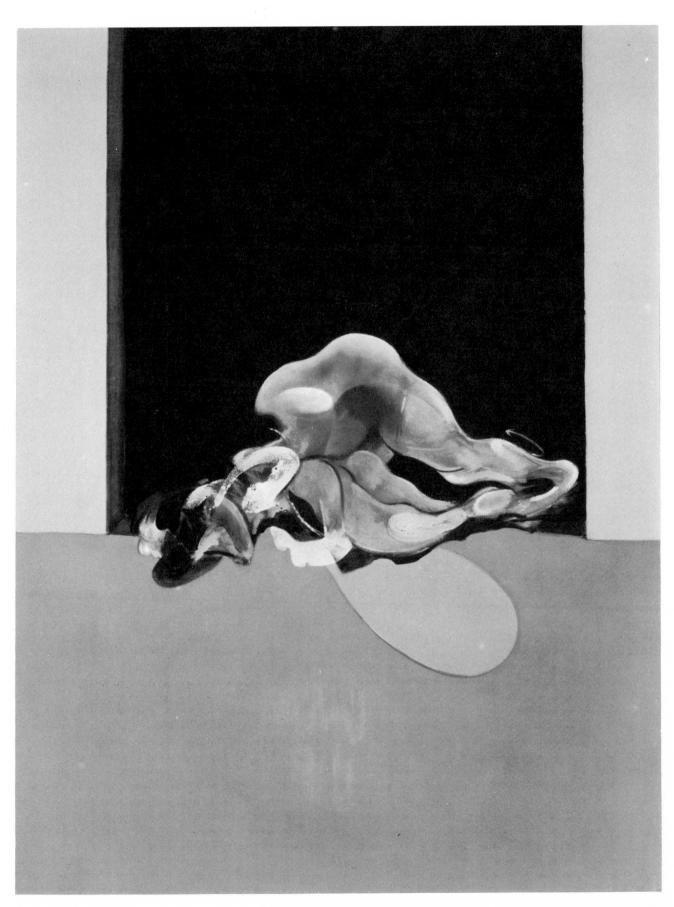

FB I suppose I'm aware, though I wasn't aware in the very distinct way in which you put it. But I think it's an indication of people's, you may say, qualities how they behave in an extreme situation.

DS Well, it seems to me that that preoccupation of yours is very relevant to your work, either overtly or implicitly. Overtly when you paint the scream – and you even impose the scream on that cool Velasquez Pope – and the Crucifixion, and people violently coupling on beds, and single figures in convulsive attitudes, and nudes injecting drugs into their arms.

FB I've used the figures lying on beds with a hypodermic syringe as a form of nailing the image more strongly into reality or appearance. I don't put the syringe because of the drug that's being injected but because it's less stupid than putting a nail through the arm, which would be even more melodramatic. I put the syringe because I want a nailing of the flesh onto the bed. But that, perhaps, is something I shall pass out of entirely.

DS Now, I wouldn't want to make too much of your overtly dramatic subjects, because, after all, a great deal of European art represents moments of high drama. What I feel is conclusive is that, when you paint a man simply sitting in a room or walking down the street, almost everyone who looks at the paintings seems to feel that this is anything but a banal or neutral situation, but that this figure is involved in some kind of crisis, perhaps some apprehension of impending doom.

FB I think you once said to me that people always have a feeling of mortality about my paintings.

DS Yes.

FB But then, perhaps, I have a feeling of mortality all the time. Because, if life excites you, its opposite, like a shadow, death, must excite you. Perhaps not excite you, but you are aware of it in the same way as you are aware of life, you're aware of it like the turn of a coin between life and death. And I'm very aware of that about people, and about myself too, after all. I'm always surprised when I wake up in the morning.

63 (Opposite) Lying Figure with Hypodermic Syringe 1963 DS Doesn't that belie your view that you're essentially an optimistic person?

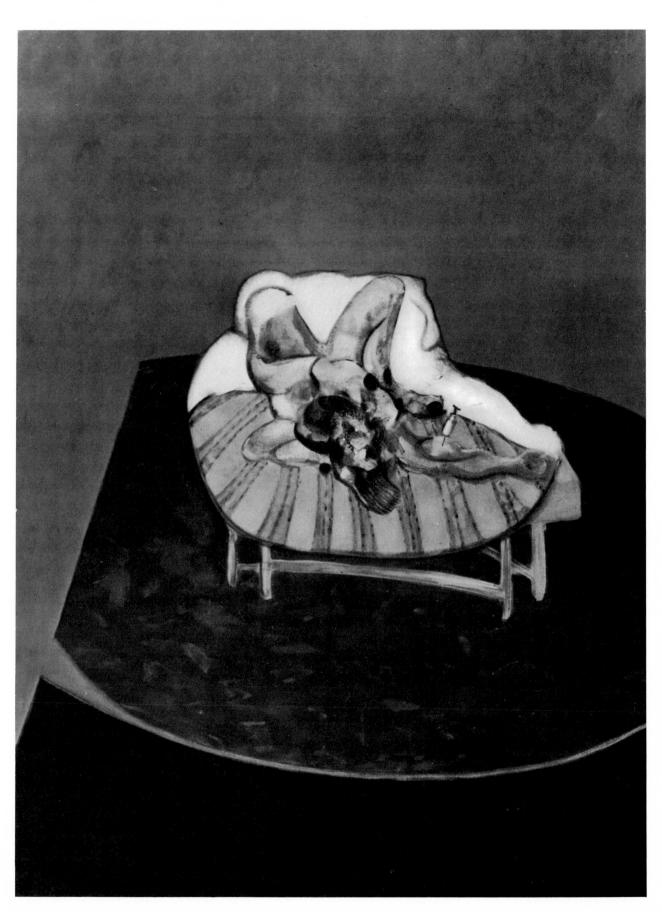

FB Ah well, you can be optimistic and totally without hope. One's basic nature is totally without hope, and yet one's nervous system is made out of optimistic stuff. It doesn't make any difference to my awareness of the shortness of the moment of existence between birth and death. And that's one thing I'm conscious of all the time. And I suppose it does come through in my paintings.

DS It does come through.

FB But does it more than in other people's paintings today?

DS Well, of course, there's not all that number who are painting the figure today. But I think it does more. And people seem to feel in looking at your figures that they are seen in moments of crisis, moments of acute awareness of their mortality, moments of acute awareness of their animal nature – moments of recognition of what might be called elemental truths about themselves.

FB But surely any art is always made up of those qualities?

DS Well, it's possibly true, say, of Rembrandt.

FB I find it true of every art that I know of that has interested me. But then I hope we're not talking at cross purposes, because we know it so well we read it into everything else too.

DS Well, it's not a quality which we get in looking at a Renoir. You might say that you're not particularly interested in Renoir.

FB Oh, I think Renoir did most beautiful landscapes. I'm not certain that I'm so interested in the figures. But, on the other hand, if one has that attitude to life that I have, and I think you probably have too, one can feel it even in these figures which appear bathed in this wonderful light of happiness on a summer afternoon. So in a sense I would be aware of it, I think, in Renoir as I would be in Degas or in Rembrandt or in Velasquez. One is particularly aware of it in Velasquez, of course. I don't know whether it's because of Velasquez's tremendous sophistication. Obviously, he was a profoundly sophisticated man living in the society of the Court, and he was probably the only really sophisticated being existing around the Court at the time; that was the reason the King insisted on keeping him near him, because he was the only man that at least enlivened for a moment his

64 VELASQUEZ Prince Philip Prosper 1659

day. But one feels in all his paintings the whole poignancy that Velasquez must have felt – even in those beautiful things where the figures have this wonderful structure and yet at the same time have the colouring of a Monet. You feel the shadow of life passing all the time.

DS But the intimations of mortality in Velasquez or Degas or even Rembrandt aren't conveyed with anything of the menace with which they are in your work, where most people seem to feel there's somehow a distinct presence or threat of violence.

FB Well, there might be one reason for this, of course. I was born in Ireland, in 1909. My father, because he was a racehorse trainer, lived not very far from the Curragh, where there was a British cavalry regiment, and I always remember them, just before the 1914 war was starting, galloping up the drive of the house which my father had and carrying out manoeuvres. And then I was brought to London during the war and spent quite a lot of time there, because my father was in the War Office then, and I was made aware of what is called the possibility of danger even at a very young age. Then I went back to Ireland and was brought up during the Sinn Fein movement. And I lived for a time with my grandmother, who married the Commissioner of Police for Kildare amongst her numerous marriages, and we lived in a sandbagged house and, as I went out, these ditches were dug across the road for a car or horse-and-cart or anything like that to fall into, and there would be snipers waiting on the edges. And then, when I was sixteen or seventeen, I went to Berlin, and of course I saw the Berlin of 1927 and 1928 where there was a wide open city, which was, in a way, very, very violent. Perhaps it was violent to me because I had come from Ireland, which was violent in the military sense but not violent in the emotional sense, in the way Berlin was. And after Berlin I went to Paris, and then I lived all those disturbed years between then and the war which started in 1939. So I could say, perhaps, I have been accustomed to always living through forms of violence - which may or may not have an effect upon one, but I think probably does. But this violence of my life, the violence which I've lived amongst, I think it's different to the violence in painting. When talking about the violence of paint, it's nothing to do with the violence of war. It's to do with an attempt to remake the violence of reality itself. And the violence of reality is not

65 MUNCH The Scream 1893

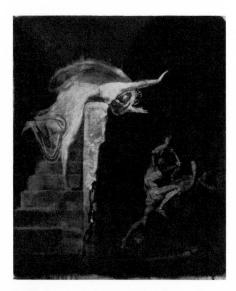

66 FUSELI Ariadne Watching the Struggle of Theseus with the Minotaur c. 1815

only the simple violence meant when you say that a rose or something is violent, but it's the violence also of the suggestions within the image itself which can only be conveyed through paint. When I look at you across the table, I don't only see you but I see a whole emanation which has to do with personality and everything else. And to put that over in a painting, as I would like to be able to do in a portrait, means that it would appear violent in paint. We nearly always live through screens – a screened existence. And I sometimes think, when people say my work looks violent, that perhaps I have from time to time been able to clear away one or two of the veils or screens.

DS One thing that's clear is that you're not concerned in your painting to say something about the nature of man, in the way that an artist like, say, Munch was.

FB I'm certainly not. I'm just trying to make images as accurately off my nervous system as I can. I don't even know what half of them mean. I'm not saying anything. Whether one's saying anything for other people, I don't know. But I'm not really saying anything, because I'm probably much more concerned with the aesthetic qualities of a work than, perhaps, Munch was. But I've no idea what any artist is trying to say, except the most banal artists; I can think what Fuseli and people like that are trying to say.

DS Perhaps the tendency to interpret your work as saying something comes from the fact that people like to try and find a story in art and are rather starved of stories in the art of our time, so that, when they find an art like yours, it's a great temptation to weave stories.

FB Yes, I'm sure it is.

DS Something similar has happened with Giacometti – the tendency to interpret his figures as Existential Man.

FB And how did he feel about that?

DS He thought it was rather crass. He said he was only trying to copy what he saw.

FB Exactly.

DS On the other hand, he wasn't only copying what he saw. He was, for one thing, crystallizing very complex feelings about the act of seeing, especially about gazing at someone

67 GIACOMETTI Head of Diego 1955

who is gazing back at you. Perhaps you'd tell me what you feel your painting is concerned with besides appearance.

FB It's concerned with my kind of psyche, it's concerned with my kind of - I'm putting it in a very pleasant way - exhilarated despair. $\Box \Box$

DS Those sculptures you used to talk about wanting to do: have you more or less given up the idea now?

FB I don't think I will do them, because I think I have now found a way by which I could do the images I thought of more satisfactorily in paint than I could in sculpture. I haven't started on them yet, but through thinking about them as sculptures it suddenly came to me how I could make them in paint, and do them much better in paint. It would be a kind of structured painting in which images, as it were, would arise from a river of flesh. It sounds a terribly romantic idea, but I see it very formally.

DS And what would the form be?

FB They would certainly be raised on structures.

DS Several figures?

FB Yes, and there would probably be a pavement raised high out of its naturalistic setting, out of which they could move as though out of pools of flesh rose the images, if possible, of specific people walking on their daily round. I hope to be able to do figures arising out of their own flesh with their bowler hats and their umbrellas and make them figures as poignant as a Crucifixion.

DS And you'd do it on single canvases or in triptychs?

FB I'd do it on a canvas; I might do triptychs of it.

DS Up to now, you've always worked – leaving aside about two exceptions – with the canvas upright, never horizontal, so that, when you've done a horizontal work, it's invariably been a triptych. Have you ever had visions of paintings you might do on a single horizontal canvas of about the same size as the large triptychs?

FB Yes, I have. I was only thinking today about that very thing – that I just might alter the whole dimensions of the canvases. I might easily do that. But I shall have to move into another studio to do it, because nothing larger will go

through my place – not even half an inch larger. Though that isn't the reason I've done triptychs.

DS When you're working on them, you don't have the three canvases up together; you do them separately?

FB I do them separately. But I know how I want them to be from the point of view of scale, one against the other, and therefore it's only a question of taking small measurements.

DS And you work on them separately to the point of completing one before going on to the next?

FB Generally.

DS After finishing the third one, do you ever go back and make modifications to the first two?

FB Yes.

DS Triptychs have been a very large part of your output in recent years. Of course, your very first major work was a triptych, back in 1944 (4). But, oddly enough, between then and 1962, I think you only did one, of heads, in 1953 – and I remember that you painted the right-hand canvas as a selfsufficient work and that I tried to sell it for you to two or three different dealers for about £60 and failed (though it was one of the best things you'd ever done) and that you then painted the other two canvases. But over the last ten years you've been doing triptychs more and more. What attracts you so much to the form?

FB I see images in series. And I suppose I could go on long beyond the triptych and do five or six together, but I find the triptych is a more balanced unit.

DS But, given a room with wallspace for six separate large canvases, if you were asked to do a series of six paintings to hang there permanently, would you find that an attractive idea?

FB Yes, very.

DS But, when the series is to be a unit, you find the triptych enough. Now, I can see what you mean about the balance in relation to the large triptychs, because in these you quite often make the two outside canvases rather similar to each other in design – sometimes almost mirror-images of each other – and use a contrasting kind of composition in the central canvas. But in the triptychs of heads you just have

68 Three Studies of the Human Head 1953

69 Detail from right-hand panel of 68

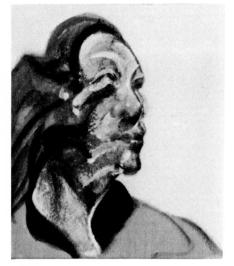

70 Three Studies of Isabel Rawsthorne on Light Ground 1965

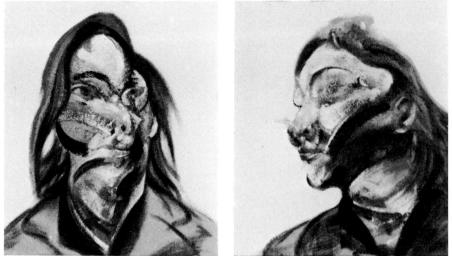

a row of heads, and one can easily imagine the row's being extended – especially as you've sometimes done a series of four heads on separate canvases and you also once put four, like a strip of film, on a single canvas. So it's interesting that you've never done a polyptych of four or five heads.

FB Well, I've sometimes thought of it. On the other hand, in the triptychs I get them rather like police records, looking side face, front face, and then side face from the other side.

DS I take it that in the triptychs it's important for you that each canvas should be contained within a frame?

FB Well, there was something very unsatisfactory, for instance, when I had the show in Paris and the Guggenheim lent their *Crucifixion* triptych (8) and the canvases were all together in one frame. It absolutely ruined the whole picture. I wrote and told them that if I'd wanted them all to be together I would have put them together. I wanted them to be in separate frames. It ruins the balance putting them together, because, if I'd wanted to do that, I would have painted them a different way. Whether they've been changed back . . . I don't suppose so. They always think that they know best.

DS Speaking of the way the work is shown, how about the glass? I know you always like to have the paintings under glass, but, when there are those large dark areas, and one sees oneself reflected in them – and also furniture and also pictures on the opposite wall – it does become very difficult to see what's there. Are the reflections something you positively want to have, or are they something to be put up with?

FB I don't want them to be there; I feel that they should be put up with. I feel that, because I use no varnishes or anything of that kind, and because of the very flat way I paint, the glass helps to unify the picture. I also like the distance between what has been done and the onlooker that the glass creates; I like, as it were, the removal of the object as far as possible.

DS So it's not that you feel that the reflections add something by adding to the scrambling of the forms?

FB Well, oddly enough, I even like Rembrandts under glass. And it's true to say in many ways they're more difficult to see, but you can still look into them.

DS Do you feel, perhaps, that having to look through the reflections forces one to look harder? Is that a factor?

FB No, it isn't. It's the distance – that this thing is shut away from the spectator.

DS When looking at Duchamp's *Large Glass*, one can also look through it and see other people and other paintings in the room at the same time as the forms on the glass. Now, in a way, through the reflections, something of the same confusion is got by your use of glass. But I take it that there's no attempt to get that.

FB There is no attempt to do what Duchamp did, which was a perfectly logical thing. Whereas to want the person reflected in the glass of a dark painting is illogical and has no meaning. I think it's just one of those misfortunes. I hope they'll make glass soon which doesn't reflect.

DS Of course, the non-reflecting glass that's been produced so far has that unfortunate effect of acting like frosted glass.

FB There's very little reflection in perspex, but it actually sucks the paint off the canvas. You can rub it with antimagnetic things, but that doesn't really work.

DS I'm told that a lot of private collectors of your work remove the glass.

FB Yes. It's the fashion to see paintings without glass nowadays. If they want to remove it, that's their business, of course. I can't stop them.

DS Do you have any feelings as to whether you prefer works of yours to be in private houses or in museums? FB I really don't mind. What I do like is space, and it depends on the space of the private house, really, or the space of the museum. I think that my paintings work better with a lot of space around them.

DS But you don't mind at all whether they're in private or in public hands and which particular hands?

FB I don't. They've gone out, and I know the ones that I like and the ones that I don't like and it doesn't worry me that my things should be seen or should be what is called appreciated. It doesn't mean anything to me. I'm glad if somebody likes them, of course, but I can't say it's a worrying thing for me at all. I believe people do actually worry who buys their paintings and where they're going to be put, but it doesn't really worry me. Perhaps I'm not public-spirited. I don't care. I would be annoyed if, for instance, people bought the things that I liked best and just destroyed them – burnt them or something like that.

DS Why would you be annoyed?

FB I would be annoyed because, for myself, I would like, if anything remains of mine when I'm dead, I would like the best images to remain.

DS But why?

FB That's just vanity. It's a thing that one will never know about because one will be dead, but nevertheless, if my things do last at all, I would like the best things to last.

DS Well, then, you mind a bit that your things should be seen.

FB When I say I care, I care because – I can only talk from an absolutely personal view – I think some of the images I have made have for me got a kind of potency about them, and so, you may say, I care that those ones should remain. But, if I think really logically, it's stupid to think even that way, because I simply won't know anything about it, any more than these people who fuss in their lifetime about whether their things are good, really, or bad, because they won't ever know. Because time is the only great critic.

DS Even so, in Shakespeare's sonnets, for example, again and again the final couplet makes the point that, long after he is dead, these lines will still be read.

FB Yes, true.

DS There's a paradox about the survival of works of art – I mean in our society, where art doesn't serve any ritual or didactic purpose. The motivation to do it is the doing of it, the excitement of solving problems, but problems of a kind that can only be solved through actually making something, so that, at the end of the process, there's this thing, the residue of the activity. Now, once having made that thing, the artist really might as well destroy it, but usually he seems to prefer to let it go on existing.

FB Well, there are two reasons for not destroying. One is that, unless you are a rich man, you want if you can to live by something it really absorbs you to try and do. The other is that one doesn't know how far the will to make this thing hasn't got already leaked into it the stupidity, you may say, of the idea of immortality. After all, to be an artist at all is a form of vanity. And that vanity may be washed over by this rationally futile idea of immortality. It would also be a vanity to suggest that what one does oneself might help to thicken life. But, of course, we do know that our lives have been thickened by great art. One of the very few ways in which life has been really thickened is by the great things that a few people have left. Well, art is, of course, a profoundly vain occupation, really.

DS Nowadays you allow a far higher proportion of your work to survive than you did twenty years ago.

FB I only think or hope that I've got a bit better.

DS You don't need to do so for financial reasons, I imagine, because the prices are so much higher now that you could probably live by releasing one or two works a year.

FB Yes, I could.

DS So you obviously feel that the work is more worth preserving?

FB I just hope that I'm going to do something so much better.

DS In the past, it was very often the best works that were destroyed, because, since they were good, you wanted to take them further, and then the paint would get clogged and you couldn't extricate them. Does this happen less than it used to do?

FB Well, I've become much more technically wily about

those sorts of bogs that I used to fall into, as you say, with the better things by trying to take them further. I can manipulate the paint now in a way that I don't have to get into the kind of marshland which I can't extricate myself from. I do go on working on them, but I do, of course, work very much more by chance now than I did when I was young. For instance, I throw an awful lot of paint onto things, and I don't know what is going to happen to it. But I do it much more than I used to.

DS Do you throw it with a brush?

FB No, I throw it with my hand. I just squeeze it into my hand and throw it on.

DS I remember you used to use a rag a lot.

FB I do use it a lot too, still. I use anything. I use scrubbing brushes and sweeping brushes and any of those things that I think painters have used. They've always used everything. I don't know, but I'm certain Rembrandt used an enormous amount of things.

DS When you throw paint, the image has reached a certain state and you want to push it further?

FB Yes, and I can't by my will push it further. I can only hope that the throwing of the paint onto the already-made image or half-made image will either re-form the image or that I will be able to manipulate this paint further into – anyway, for me – a greater intensity.

DS I know this is an impossible question because it can't be answered in a general way, but, very broadly speaking, do you tend to throw paint quite often in the course of working on a picture, or once in a couple of hours, or what?

FB Well, that is difficult. It might happen quite often, or it might happen only once and the thing comes more right, if you see what I mean, and I don't need to throw it again.

DS And what about the use of scrubbing brushes and rags and so on? Do you tend to use a rag fairly continually?

FB Yes.

DS To rub out what you've put?

FB No, not to rub out. I impregnate rags with colour, and they leave this kind of network of colour across the image. I use them nearly always. DS Can you conceive of getting to a stage where you had such freedom in your handling of the brush that it became unnecessary to interrupt the process with other practices?

FB But I use those other practices just to disrupt it. I'm always trying to disrupt it. Half my painting activity is disrupting what I can do with ease.

DS About this problem of chance, an example of a work made very much according to chance would be Duchamp's *Three Standard Stoppages* of 1913, where he took three threads each a metre in length, dropped each of them from the height of a metre onto a separate canvas stained Prussian blue, and fixed them there as they had fallen. Now, however much the concept of this work reflects a very idiosyncratic

71 DUCHAMP Three Standard Stoppages 1913–14

genius, when it came to the random factor it seems likely that Duchamp could have asked his cleaner to come in and drop the threads. But could you ask your cleaner to come in, take a handful of paint, and at a certain moment, chosen by you, throw it at the canvas? Is it conceivable that she might get useful results?

FB Quite conceivable. But she would probably think it was immoral and she wouldn't do it.

DS In other words, you're saying that the throwing of the paint really is random?

FB Yes.

DS But if someone other than yourself were given the moment when to throw the paint and the choice of what paint to throw, what colour to throw, what consistency to throw, there'd be an enormous amount of decision on your part, even allowing that somebody else could throw the paint as usefully as you could.

FB I know the part of the canvas I want to throw at, so I would have to tell them what part of the canvas to throw at. and, since I've thrown an awful lot, perhaps I'd know how to aim better onto that part. But I'm not suggesting that somebody else couldn't come in and throw it and might not then create another image altogether or a better image. I'm always hoping for that. But I don't think, perhaps, my paintings look like that. For instance, I would loathe my paintings to look like chancy abstract expressionist paintings, because I really like highly disciplined painting, although I don't use highly disciplined methods of constructing it. I think the only thing is that my paint looks immediate. Perhaps it's a vanity to say that, but at least I sometimes think, in the better things, the paint has an immediacy, although I don't think it looks like thrownabout paint.

DS But this chance is really very controlled when you come to think of it. Because, apart from the moment of decision as to when to throw, and apart from the consistency and choice of colour, and apart from the choice of the part of the painting at which it is to be thrown, there is also the angle and force at which it is to be thrown, which obviously depends very much on practice and knowing the kinds of things that happen when the paint is thrown at a certain velocity and at a certain angle.

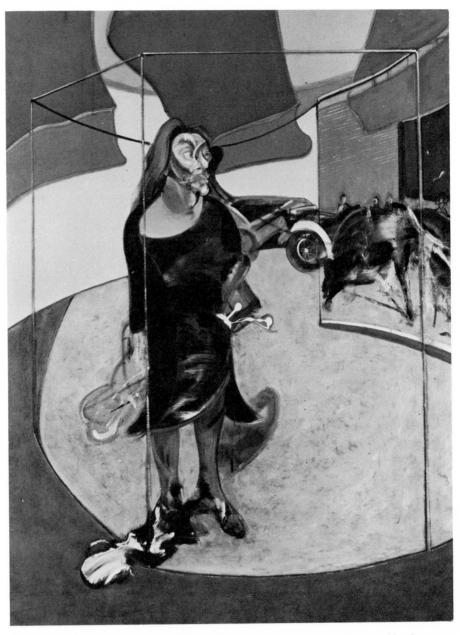

72 Portrait of Isabel Rawsthorne Standing in a Street in Soho 1967

FB But paint is so malleable that you never do really know. It's such an extraordinary supple medium that you never do quite know what paint will do. I mean, you even don't know that when you put it on wilfully, as it were, with a brush – you never quite know how it will go on. I think you probably know more with acrylic paint, which all the new painters use.

DS You don't use acrylic at all?

FB I do use acrylic sometimes for the background.

DS But do you not feel that with experience you are more aware of the kinds of thing that are likely to happen when you throw paint?

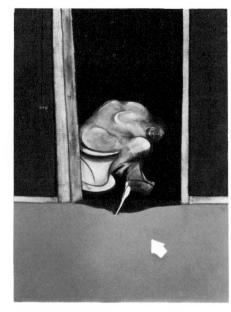

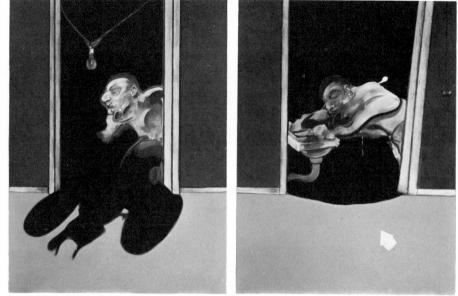

73 Triptych – May-June 1973

FB Not necessarily. Because I very often throw it and then take a great sponge or rag and sponge it out, and that in itself leaves another totally different kind of form. You see, I want the paintings to come about so that they look as though the marks had a sort of inevitability about them. I hate that kind of sloppy sort of Central European painting. It's one of the reasons I don't really like abstract expressionism. Quite apart from its being abstract, I just don't like the sloppiness of it.

DS It's like what you said before; it's using chance to get a controlled-looking result. And, in fact, it is always highly controlled, inasmuch as you would never end a painting by suddenly throwing something at it. Or would you?

FB Oh yes. In that recent triptych, on the shoulder of the figure being sick into the basin, there's like a whip of white paint that goes like that. Well, I did that at the very last moment, and I just left it. I don't know if it's right, but for me it looked right.

DS Now, had it not looked right, could you have taken the knife and removed it?

FB I could. As that background is a very thinly painted mixture of Prussian blue and black, I could have taken the knife. I would then have had to scrub it, that background, and reapply the paint, because I wanted it to be very thin and I'd have had to just try again and see. This just happened – well, at least, I thought – right. Of course Frank Auerbach

74 (Opposite) Right-hand panel of 73

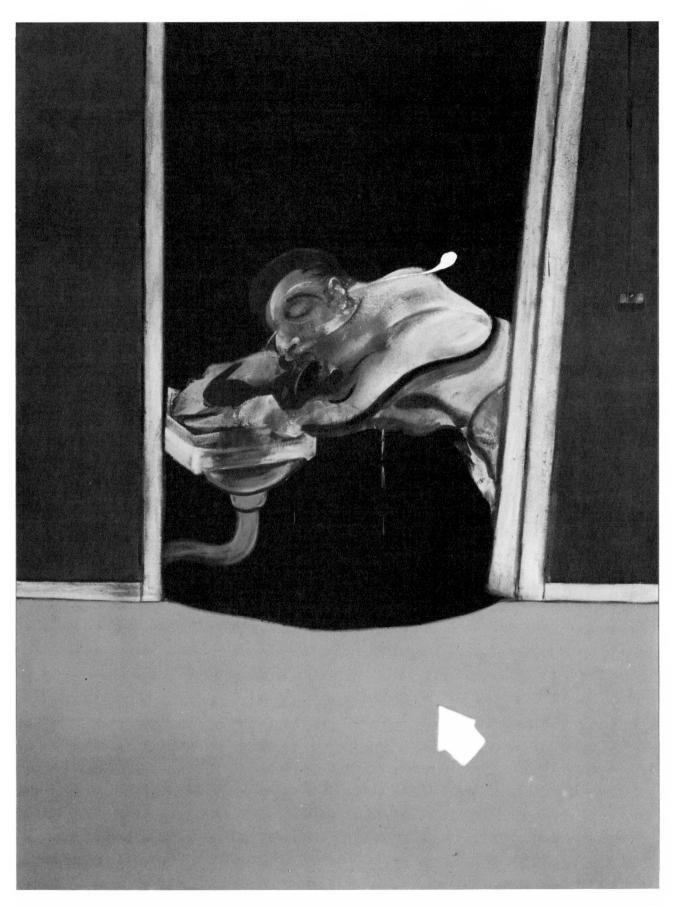

says what I call accident isn't accident at all. But then what else can I call it?

DS What does he say it is?

FB Well, you see, he can't define what it is, if it's not accident and chance. He can't define what it is. Can you?

DS Well, there is something that I wonder whether it's like, and that is this strange feeling you sometimes get in playing ball games, when you play a shot and feel that you didn't play the shot but it played you. Now, obviously you can only play a shot like that when you've practiced your swing and have got your action into a certain groove. And then suddenly in the middle of a game somebody will play a very good shot and in reply you will play a better shot than you thought you could ever possibly play. The very difficulty makes your own shot that much better, and you're amazed and don't know how you did it, hardly believe you did it.

FB Exactly.

DS And obviously there was no way of preparing for it, there wasn't time, and the very fact that there wasn't time made the shot play itself.

FB Well, it is in a way inspired chance when those things happen. Of course it's based on the fact that you know a great deal about the game you're playing. But nevertheless you wouldn't probably have done that particular thing by will-power.

DS Absolutely not. You'd have tensed up. But of course in making art, and this also applies to playing games, there is a kind of trance-like state you can get into. I imagine that Cézanne was talking about that kind of state when he said that, if he took thought when painting, everything was lost. Do you feel you're in that kind of state when things are going well?

FB I don't like using the word trance-like nowadays, because it comes too near to modern mysticism, which I hate. I also think, perhaps, it sounds slightly pompous to say it's a trance-like state; do you know what I mean?

DS Yes, indeed, I know it's slightly pompous, but I don't know what else one could say.

FB No, it's very difficult.

DS It's acting by instinct.

FB It is. But then all art surely is instinct, and then you can't talk about instinct, because you don't know what it is.

DS But it's an instinct rooted in cultivation and practice and knowledge.

FB I think so. Because we know, for instance, the instinctive art of children, but yet it's a totally different type of instinct, and very unsatisfactory finally.

DS Now, as to the interaction between, say, throwing paint at the canvas and then manipulating that paint, I raised the question before whether the cleaner could come and do the throwing equally well if she had no inhibitions about doing it and followed your instructions. But I'm now going to say that maybe the cleaner simply couldn't, and that there must be a kind of continuity of rhythm in your relationship to the canvas by which the conscious manipulation, the throwing of paint and the continuation of conscious manipulation are all part of one process.

FB I wouldn't like to exclude the idea that somebody could come in and do it as well or better. I wouldn't like to cancel out that it could happen; because I think it could happen. It might be different, it might be better, or it might be worse. Of course they wouldn't know what to do with it afterwards.

DS Naturally. Now, on a day when, say, you're in form, do you find that, when your conscious activity is going well, the accidental activity will also be going well?

FB Yes. And one of the things is, of course, that in one's conscious activity in painting – at any rate in oil painting, which is such a fluid and curious medium – often the tension will be completely changed by just the way a stroke of the brush goes on. It breeds another form that the form you're making can take. I mean, there are all sorts of things happening all the time, and it's difficult to distinguish between the conscious and the unconscious working, or the instinctive working, whichever you like to call it.

DS And aren't the good days those days when areas open up which you hadn't predicted? Those are precisely what good days are, aren't they?

FB Yes, of course.

DS But then this does tend, I would say, to give the lie to the idea that the cleaner could get equally good results.

FB The thing is that, if you were just going to leave the one piece of thrown paint, they might be able to, but, if you're going to manipulate, obviously not.

DS But even apart from the manipulation.

FB Well, hazard plays such odd tricks, one doesn't know.

DS We've talked before about roulette and about the feeling one sometimes has at the table that one is kind of in tune with the wheel and can do nothing wrong. How does this relate to the painting process?

FB Well, I'm sure there certainly is a very strong relationship. After all, Picasso once said: I don't need to play games of chance, I'm always working with it myself.

DS Well, unlike the cleaner, the roulette wheel really is a machine. One might say that, while the roulette wheel really does work according to the laws of chance, somehow, when one is playing in an inspired way, it's as if it didn't – it's as if it were working according to certain laws which were not those of chance and that somehow you could get on the wave-length of the way it's working on that particular day.

FB Well, that is one of those curious things that one doesn't know anything about. It's rather like when I did once make quite a lot of money, for me at any rate, playing roulette and I did actually think I could hear the numbers being called before they came up. But one can't say whether those particular things are in fact so-called extra-sensory perception or if they are really just a run of luck.

DS And with the painting?

FB Well, again, I don't think one really knows whether it's a run of luck or whether it's instinct working in your favour or whether it's instinct and consciousness and everything intermingling and working in your favour.

DS Then isn't that what Frank Auerbach means when he says it's not really accident at all?

FB It may be what he means, it may be what he means. I don't know with Frank, because he always wants to be contradictory with me.

DS Perhaps he means that the operations you think of as random are more an inspired kind of letting-go and that the

difference between these and the manipulation is one of degree rather than kind.

FB I know that sometimes, when I've been working and things were going so badly, I've just taken a brush and put the paint anywhere, not knowing consciously what I was doing, and suddenly the thing has sometimes begun to work.

DS That sounds awfully conclusive. What I think I've been trying to suggest is that accident is always present and control is always present and there's a tremendous overlap between the two.

FB Yes, I think there is, I think that is so. And yet, what socalled chance gives you is quite different from what willed application of paint gives you. It has an inevitability very often which the willed putting-on of the paint doesn't give you.

DS Is that because with the willed putting-on one kind of tightens up? Is that what illustration means? -a kind of caution, a lack of relaxation?

75 Detail from right-hand panel of 91

FB Well, illustration surely means just illustrating the

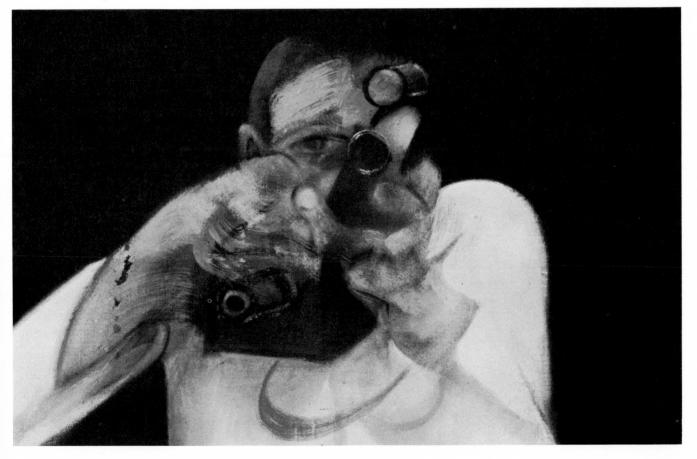

78 (Opposite) Sleeping Figure 1974

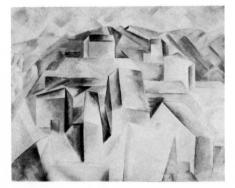

76 PICASSO Houses on a Hill (Horta de San Juan) 1909

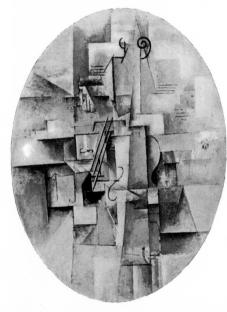

77 PICASSO Still Life with a Violin 1911–12

image before you, not inventing it. I don't know how I can say any more about it than what you know. Because, you see, it's impossible to talk about chance when you don't know what it is. When people like Frank say it isn't chance or accident or whatever you like to call it, in a way I know what they mean. And yet I don't know what they mean, because I don't think one can explain it. It would be like trying to explain the unconscious. It's also always hopeless talking about painting – one never does anything but talk around it – because, if you could explain your painting, you would be explaining your instincts.

DS No, you can't explain your painting, and nobody can explain their own painting or any painting, but you can throw light on your painting.

FB I don't know what it's about myself. I don't really know how these particular forms come about. I'm not by that suggesting that I'm inspired or gifted. I just don't know. I look at them – I look at them, probably, from an aesthetic point of view. I know what I want to do, but I don't know how to do it. And I look at them almost like a stranger, not knowing how these things have come about and why have these marks that have happened on the canvas evolved into these particular forms. And then, of course, I remember what I wanted to do and I do, of course, try then and push these irrational forms into what I originally wanted to do.

DS I think that the best works of modern artists often give the impression that they were done when the artist was in a state of not knowing - for example, Picasso and Braque in those very late analytical-cubist pictures, where the whole thing seems totally inexplicable and one really can't believe that they knew what they were doing. They may have contructed a whole theoretical rationalization around it, and in the early analytical-cubist pictures it's fairly clear what is happening: you can more or less analyze the dislocations and the relationship of the forms to reality. But when you get to the very late analytical-cubist works, there's a totally mysterious relationship to reality which you can't begin to analyze, and you sense that the artist didn't know what he was doing, that he had a kind of rightness of instinct and that only instinct was operating, and that somehow he was working beyond reason.

FB Surely this is the cause of the difficulty of painting today – that it will only catch the mystery of reality if the

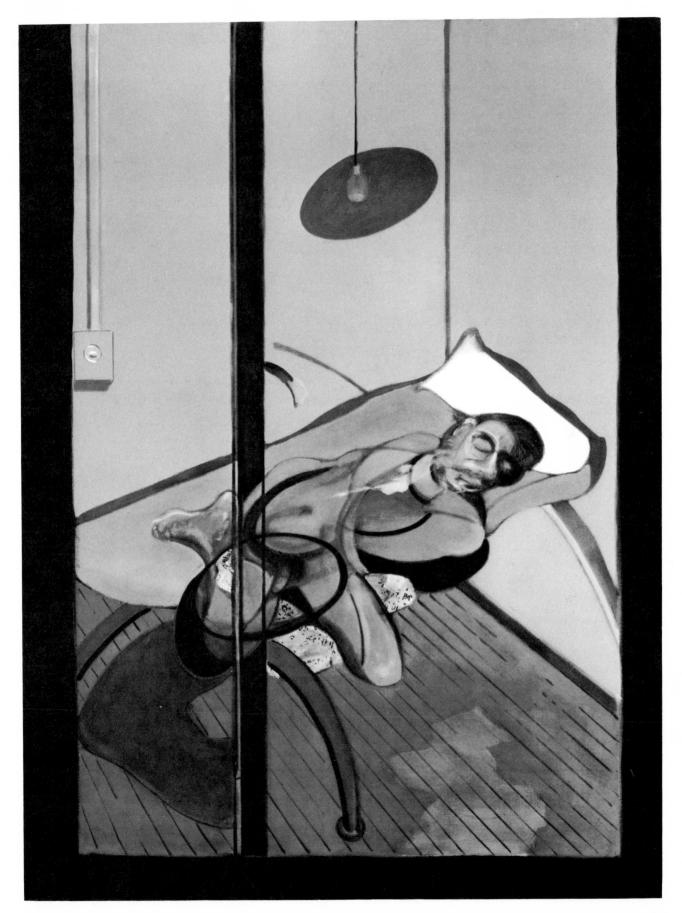

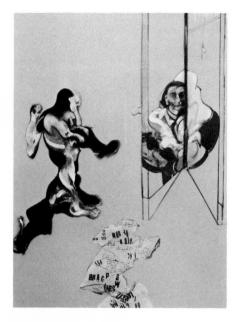

79 Triptych – Studies from the Human Body 1970

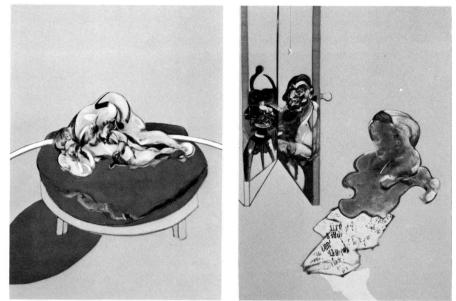

painter doesn't know how to do it. And he's carried along by his passion and he doesn't perhaps even know quite what these marks will make, and yet, in a funny way.... I don't know about the cubist painters, whether they knew what they wanted to do. As you say, with early analytical cubism you can just literally see the town on a hill and all that kind of thing – they've just been cubed up. But perhaps in the later ones Picasso knew what he wanted to do but didn't know how to bring it about. I don't know about that. I know that, in my case, I know what I want to do but don't know how to bring it about. And that's what I'm hoping accidents or chance or whatever you like to call it will bring about for me. So that it's a continuous thing between what may be called luck or hazard, intuition and the critical sense. Because it's only kept hold of by the critical sense, the criticism of your own instincts about how far this given form or accidental form crystallizes into what you want.

DS When it has crystallized for you, do you know it immediately or do you need a few weeks or months to be sure?

FB Well, if my work goes at all well, it goes very quickly. For instance, in the orange triptych of 1970 which you said that you quite liked, where the centre panel has two figures on a bed – well, I knew that I wanted to put two figures together on a bed, and I knew that I wanted them in a sense either to be copulating or buggering – whichever way you like to put it – but I didn't know how to do it so that it would have the strength of the sensation which I had about it. I

80 (Opposite) Centre panel of 79

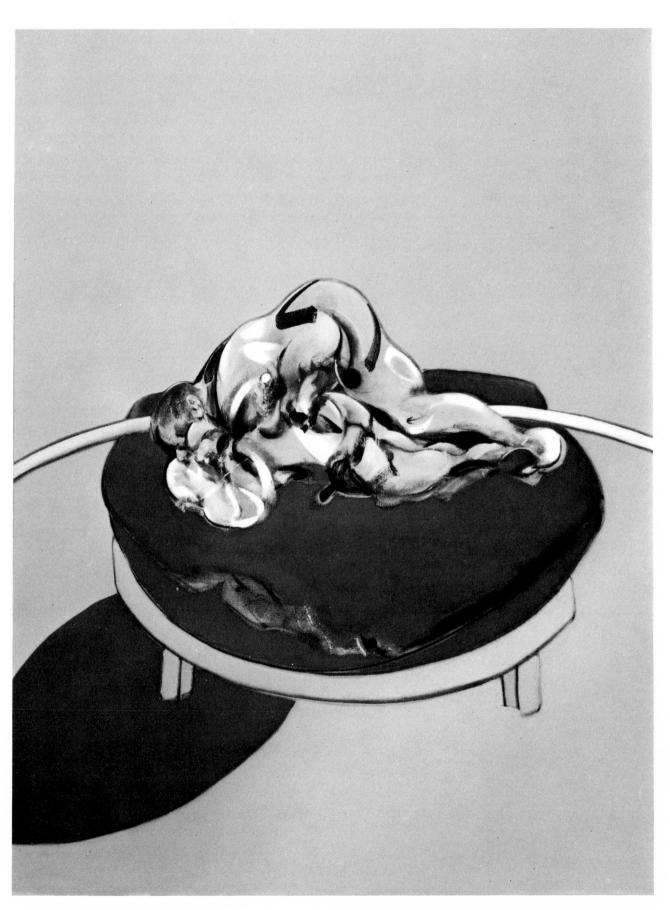

just had to leave it to chance to attempt to make an image. I wanted to make an image which coagulated this sensation of two people in some form of sexual act on the bed, but then I was left completely in the void and left absolutely to the haphazard marks which I make all the time. And then I worked on what's called the given form. And, if you look at the forms, they're extremely, in a sense, unrepresentational. One of the things I've always tried to analyze is why it is that, if the formation of the image that you want is done irrationally, it seems to come onto the nervous system much more strongly than if you knew how you could do it. Why is it possible to make the reality of an appearance more violently in this way than by doing it rationally? Perhaps it's that, if the making is more instinctive, the image is more immediate.

DS Yet, along with this need to act freely and instinctively, there's also the need, as you said, for your critical sense to keep hold. I suppose the whole of art lies in this mysterious conjunction of being able to let go and yet being able to remain sufficiently apart to see where one has to stop.

FB In my case, there's also another thing – that I really like very formal art, and I think, perhaps, as I tend to get older, I try and make it in a sense freer and yet more formal. And that again is a problem. But I think that what you say is, of course, the core of this thing. There's an extremely good lecture which Duchamp gave in 1958, I think, in Houston.

DS I'll get it off the shelf. What about this? 'To all appearances, the artist acts like a mediumistic being who, from the labyrinth beyond time and space, seeks his way out to a clearing.'

FB Where he's using 'medium', you use 'trance'.

DS 'If we give the attributes of a medium to the artist, we must then deny him the state of consciousness on the aesthetic plane about what he is doing or why he is doing it. All his decisions in the artistic execution of the work rest with pure intuition and cannot be translated into a self-analysis, spoken or written, or even thought out.' And later he says this: 'In the creative act, the artist goes from intention to realization through a chain of totally subjective reactions. His struggle towards the realization is a series of efforts, pains, satisfactions, refusals, decisions, which also cannot and must not be fully self-conscious, at least on the aesthetic plane.'

FB Yes, they cannot be. It's not that they must not be. They cannot be.

DS Does that help to disentangle what we've been talking about?

FB Not exactly, not quite. Because there is a difference. Most of Duchamp is figurative, but I think he made sort of symbols of the figurative. And he made, in a sense, a sort of myth of the twentieth century, but in terms of making a shorthand of figuration. Well, now, what personally I would like to do would be, for instance, to make portraits which were portraits but came out of things which really had nothing to do with what is called the illustrational facts of the image; they would be made differently, and yet they would give the appearance. To me, the mystery of painting today is how can appearance be made. I know it can be illustrated, I know it can be photographed. But how can this thing be made so that you catch the mystery of appearance within the mystery of the making? It's an illogical method of making, an illogical way of attempting to make what one hopes will be a logical outcome – in the sense that one hopes one will be able to suddenly make the thing there in a totally illogical way but that it will be totally real and, in the case of a portrait, recognizable as the person.

DS Could one put it like this? – that you're trying to make an image of appearance that is conditioned as little as possible by the accepted standards of what appearance is.

FB That's a very good way of putting it. There's a further step to that: the whole questioning of what appearance is. There are standards set up as to what appearance is or should be, but there's no doubt that the ways appearance can be made are very mysterious ways, because one knows that by some accidental brushmarks suddenly appearance comes in with a vividness that no accepted way of doing it would have brought about. I'm always trying through chance or accident to find a way by which appearance can be there but remade out of other shapes.

DS And the otherness of those shapes is crucial.

FB It is. Because, if the thing seems to come off at all, it comes off because of a kind of darkness which the otherness

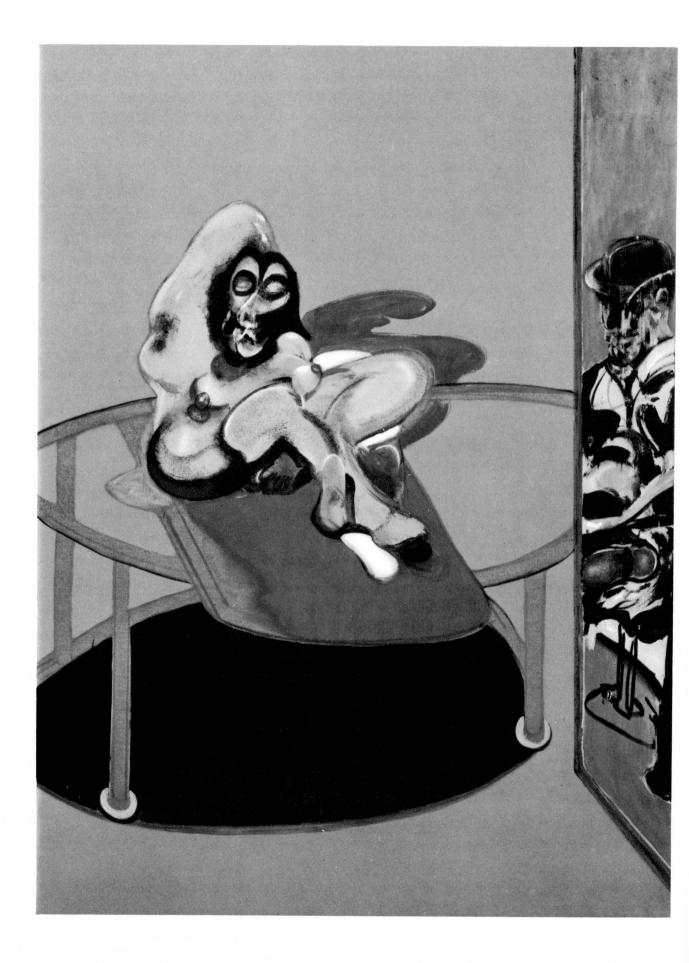

81 Study of Nude with Figure in a Mirror 1969 of the shape which isn't known, as it were, conveys to it. For instance, one could make a mouth in a way – I mean, it comes about sometimes, one doesn't know how – I mean you could draw the mouth right across the face as though it was almost like the opening of the whole head, and yet it could be like the mouth. But, in trying to do a portrait, my ideal would really be just to pick up a handful of paint and throw it at the canvas and hope that the portrait was there.

DS I can see why you would want the painting to look as if it had come about in that way, but do you mean you actually want to do that?

Well, I've tried often enough. But it's never worked that FB way. I think I would like it to happen that way because, as you know perfectly well, if you have somebody painting your room, when he puts the first brushstroke on the wall, it's much more exciting than the finished wall. And, although I may use, or appear to use, traditional methods, I want those methods to work for me in a very different way to that in which they have worked before or for which they were originally formed. I'm not attempting to use what's called avant-garde techniques. Most people this century who have had anything to do with the avant garde have wanted to create a new technique, and I never have myself. Perhaps I have nothing to do with the avant garde. But I've never felt it at all necessary to try and create an absolutely specialized technique. I think the only man who didn't limit himself tremendously by trying to change the technique was Duchamp, who did it enormously successfully. But, although I may use what's called the techniques that have been handed down, I'm trying to make out of them something that is radically different to what those techniques have made before.

DS Why do you want it to be radically different?

FB Because I think my sensibility is radically different, and, if I work as closely as I can to my own sensibility, there is a possibility that the image will have a greater reality.

DS And do you still have that obsession you used to talk about having with doing the one perfect image?

FB No, I don't now. I suppose, as I get older, I feel I want to cover wider areas. I don't think that I have that other feeling any longer – perhaps because I hope to go on painting until I die and, of course, if you did the one absolutely perfect image, you would never do anything more. $\Box \Box$ DS I've found that quite a number of the paintings you've done in the last three or four years – especially paintings of the nude – have tended to remind me that for some time now you've been talking about wanting to do sculpture. Do you yourself feel that thinking about doing sculpture has had any effect on the way you've been painting?

FB Yes, I think it's quite possible. Because for several years now I've been very much thinking about sculpture, though I haven't ever yet done it, because each time I want to do it I get the feeling that perhaps I could do it better in painting. But now I have decided to make a series of paintings of the sculptures in my mind and see how they come out as paintings. And then I might actually start on sculpture.

DS Can you give any sort of description of sculptures that you've thought of doing?

FB I've thought about sculptures on a kind of armature, a very large armature made so that the sculpture could slide along it and people could even alter the position of the sculpture as they wanted. The armature would not be as important as the image, but it would be there to set it off, as I have very often used an armature to set off the image in paintings. I've felt that in sculpture I would perhaps be able to do it more poignantly.

DS Would the armature be anything like the sorts of rail which you've sometimes used in paintings – for instance,

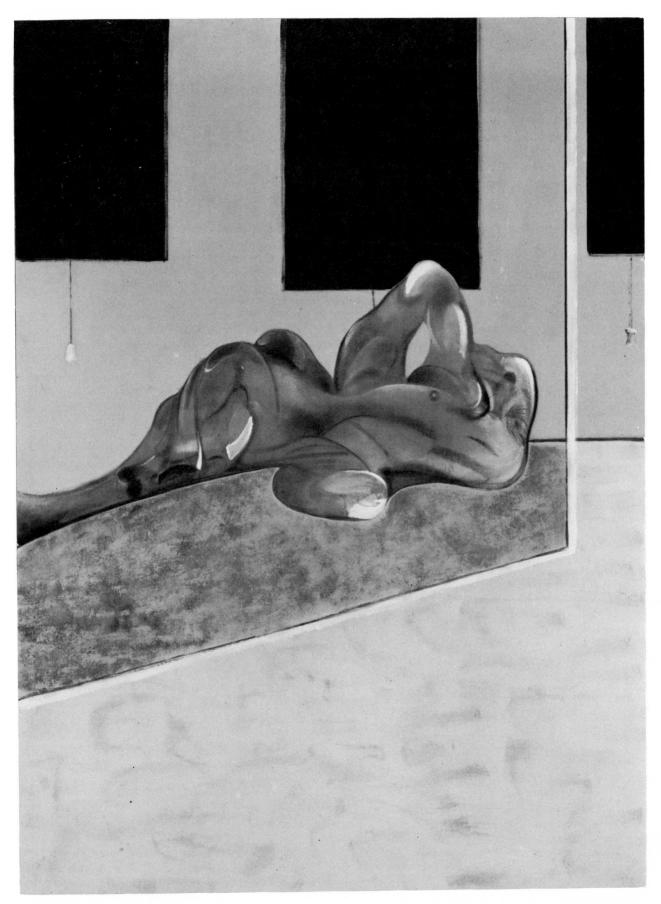

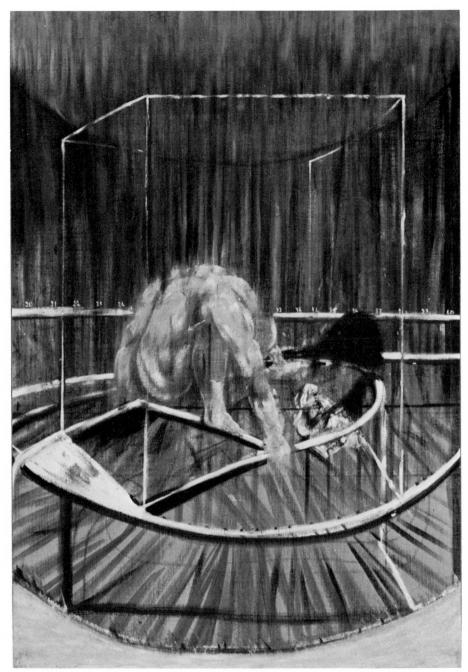

83 Study for Crouching Nude 1952

84 (Opposite) After Muybridge – Woman Emptying Bowl of Water and Paralytic Child on All Fours 1965 that crouching male nude of 1952 or the picture done in 1965 with a woman and a child taken from Muybridge?

FB Yes. I've thought of the rail in very highly-polished steel and that it would be slotted so that the image could be screwed into place in different positions.

DS Have you visualized the colours and textures of the images?

FB I would have to talk to somebody who technically understood sculpture much more than I do, but I myself have

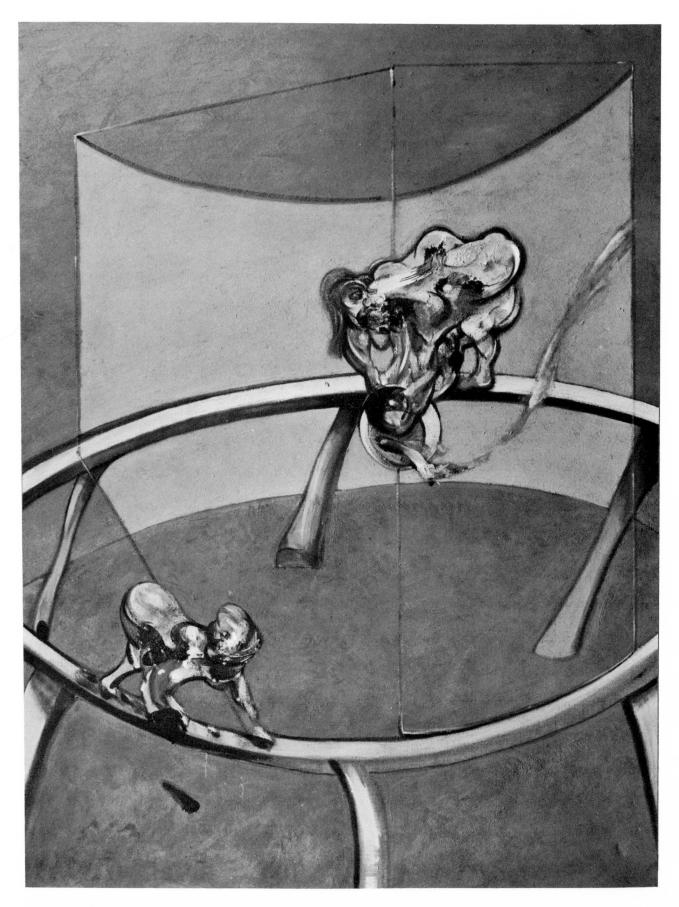

thought they should be cast in a very thin bronze – not in some kind of plastic, because I would want them to have the weight of bronze – and I've wanted to throw over them a coat of flesh-coloured whitewash, so that they'd look as though they had been dipped into an ordinary kind of whitewash, with the sort of texture of sand and lime that you get. So that you would have the feeling of this flesh and this highly-polished steel.

DS And what sort of scale have you seen them as having?

FB I've seen the armature as a very large space, like a street, and the images as comparatively small in relation to the space. The images would be naked figures, but not literal naked figures; I've seen them as very formal images of figures in different attitudes, either single or coupled. Whether I do them or not, I shall certainly try and do them in painting, and I hope I shall be able to do them in sculpture if they come off at all in the paintings. I shall probably do them in painting on the reverse side of the canvas, which might give some illusion of how they might look if they were left in space.

DS Of course, the *Three Studies for Figures at the Base of* a *Crucifixion* of 1944 (4) are clearly defined plastic forms which could almost be copied in sculpture.

FB Well, I thought of them as the Eumenides, and at the time I saw the whole Crucifixion in which these would be there instead of the usual figures at the base of the cross. And I was going to put these on an armature around the cross, which itself was going to be raised, and the image on the cross was to be in the centre with these things arranged around it. But I never did that; I just left these as attempts.

DS There's a very recent painting with a figure of a man seated in a room facing a window and outside the window a kind of phantasmal figure which is once more, you've said, a representation of the Eumenides. And that phantasm, it seems to me, is about as purely and simply sculptural as the 1944 Eumenides. But it's the figure of the man in this painting, or that reclining figure with window-blinds in the background which you painted three years ago (82) that strike me as typical of the way the figures tend to be sculptural now. It's more complex now, because now, when you create a defined sculptural form, it's qualified through nuances in the paint which create many suggestions and ambiguities. Nevertheless, those figures have a very emphatic plasticity.

85 (Opposite) Seated Figure 1974

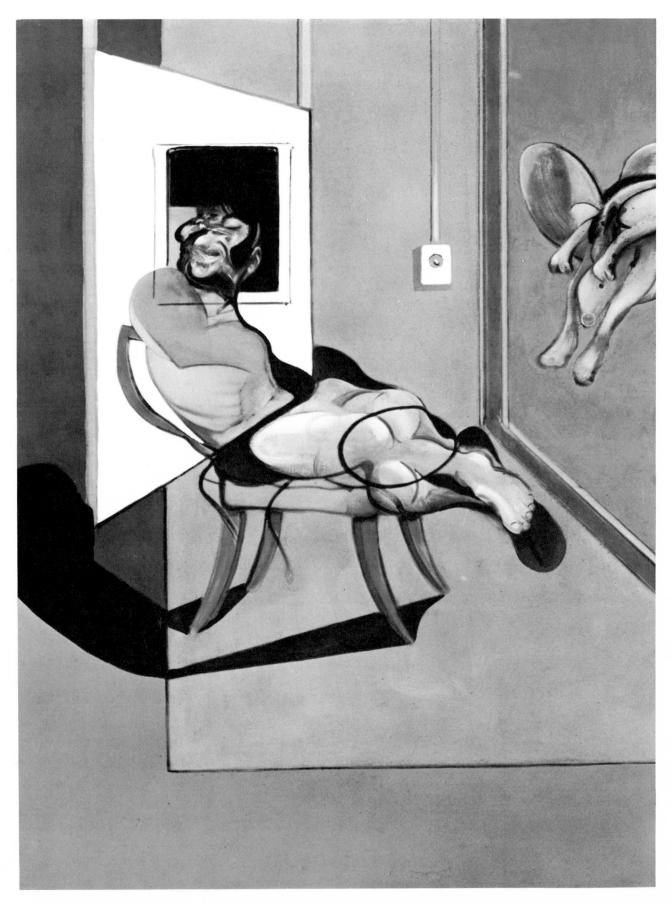

FB Well, I would like now – and I suppose it's through thinking about sculpture – I would like, quite apart from the attempt to do sculpture, to make the painting itself very much more sculptural. I do see in these images the way in which the mouth, the eyes, the ears could be used in painting so that they were there in a totally irrational way but a more realistic way, but I haven't come round yet to seeing quite how that could be done in sculpture. I might be able to come round to it. I do see all the time images that keep on coming up which are more and more formal and more and more based upon the human body, yet taken further from it in imagery. And I would like to make the portraits more sculptural, because I think it is possible to make a thing both a great image and a great portrait.

DS It's very interesting that you associate the idea of the great image with sculpture. Perhaps this goes back to your love of Egyptian sculpture?

FB Well, it's possible. I think that perhaps the greatest images that man has so far made have been in sculpture. I'm thinking of some of the great Egyptian sculpture, of course, and Greek sculpture too. For instance, the Elgin Marbles in the British Museum are always very important to me, but I don't know if they're important because they're fragments, and whether if one had seen the whole image they would seem as poignant as they seem as fragments. And I've always thought about Michelangelo; he's always been deeply important in my way of thinking about form. But although I have this profound admiration for all his work, the work that I like most of all is the drawings. For me he is one of the very greatest draughtsmen, if not the greatest.

DS I've often suspected, since as far back as 1950, that, with many of your nude figures, certain Michelangelo images had been there in the back of your mind at least, as prototypes of the male figure. Do you think this has been the case?

FB Actually, Michelangelo and Muybridge are mixed up in my mind together, and so I perhaps could learn about positions from Muybridge and learn about the ampleness, the grandeur of form from Michelangelo, and it would be very difficult for me to disentangle the influence of Muybridge and the influence of Michelangelo. But, of course, as most of my figures are taken from the male nude, I am sure that I have been influenced by the fact that Michelangelo made the most voluptuous male nudes in the plastic arts.

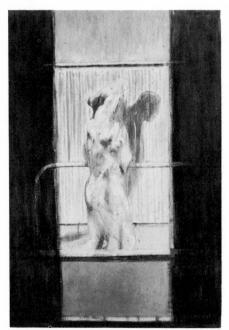

86 Painting 1950

87 (Opposite) MICHELANGELO Sheet of studies 1511 and 1513

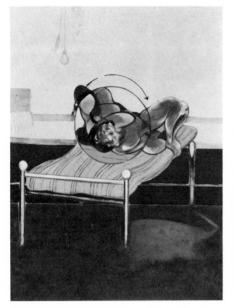

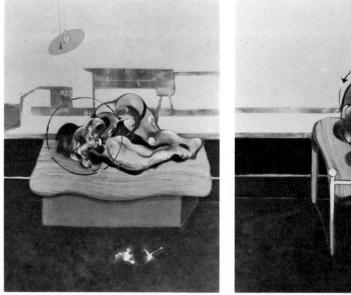

88 Three Studies of Figures on Beds 1972

90 (Opposite) Centre panel of $88\,$

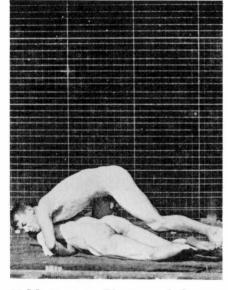

89 MUYBRIDGE Photograph from The Human Figure in Motion 1887

DS Do you think that certain Michelangelo images of figures entwined have had an influence on your coupled figures?

FB Well, these have very often been taken from the Muybridge wrestlers – some of which appear, unless you look at them under a microscope, to be in some form of sexual embrace. Actually, I've often used the wrestlers in painting single figures, because I find that the two figures together have a thickness that gives overtones which the photographs of single figures don't have. But I don't only look at Muybridge photographs of the figure. I look all the time at photographs in magazines of footballers and boxers and all that kind of thing – especially boxers. And I also look at animal photographs all the time. Because animal movement and human movement are continually linked in my imagery of human movement.

DS And are the nudes, at the same time, closely related to the appearance of specific people? Are they to some extent portraits of bodies?

FB Well, it's a complicated thing. I very often think of people's bodies that I've known, I think of the contours of those bodies that have particularly affected me, but then they're grafted very often onto Muybridge's bodies. I manipulate the Muybridge bodies into the form of the bodies I have known. But, of course, in my case, with this disruption all the time of the image – or distortion, or whatever you

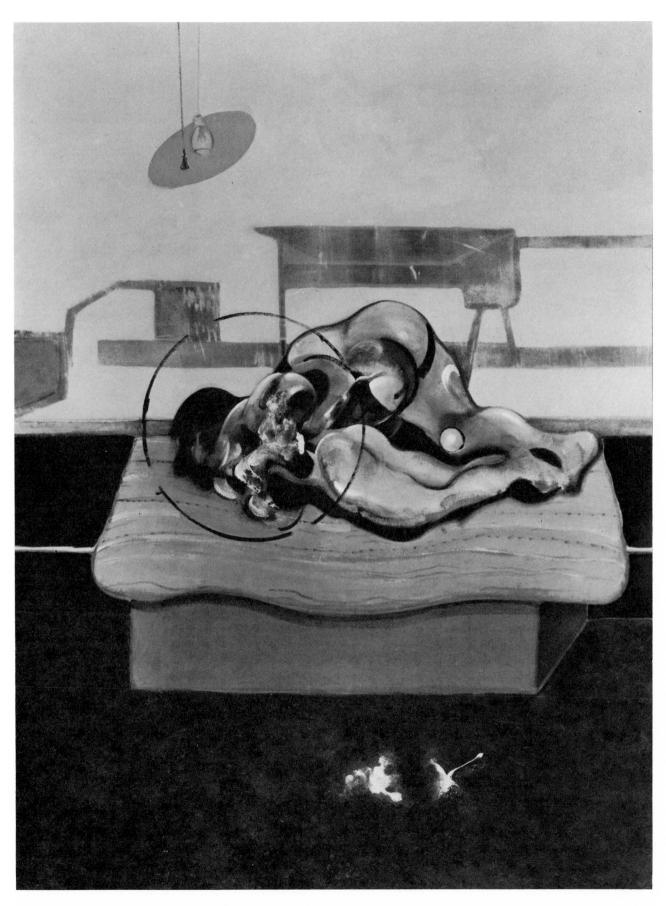

91 Triptych – March 1974

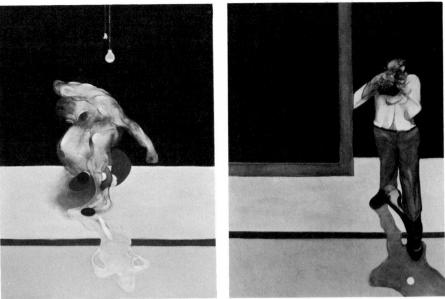

like to call it – it's an elliptical way of coming to the appearance of that particular body. And the way I try to bring appearance about makes one question all the time what appearance is at all. The longer you work, the more the mystery deepens of what appearance is, or how can what is called appearance be made in another medium. And it needs a sort of moment of magic to coagulate colour and form so that it gets the equivalent of appearance, the appearance that you see at any moment, because so-called appearance is only riveted for one moment as that appearance. In a second you may blink your eyes or turn your head slightly, and you look again and the appearance has changed. I mean, appearance is like a continuously floating thing. And, of course, in sculpture the problem is perhaps even more poignant because the material which you would be working in is not as fluid as oil paint and it would add another difficulty. But then an added difficulty often is what makes the solving of a thing deeper. Because of the difficulty in doing it.

DS It seems to me that in your painting you've confronted an immense and extraordinary kind of difficulty which possibly relates to your desire that the form should be at once very precise and very ambiguous. In that triptych of 1944 (4) you used a hard bright ground for very precisely and simply displayed forms, carved-out forms, as it were, and that was entirely consistent. Then the handling of the forms became *malerisch*, and with this the background became softer, more tonal, often curtained, and all that was entirely consistent. But then you got rid of the curtains; you came to

92 (Opposite) Centre panel of 91

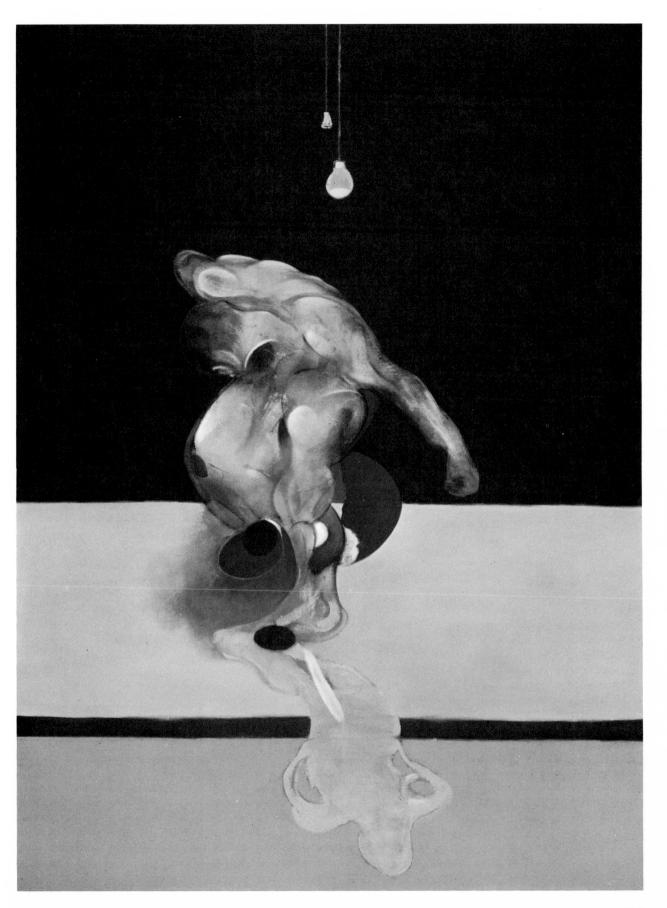

combine a *malerisch* handling of the form – and with the paint getting more and more scrambled – with a hard, flat, bright ground, so that you violently juxtapose two opposite conventions.

FB Well, I've increasingly wanted to make the images simpler and more complicated. And for this to work, it can work more starkly if the background is very united and clear. I think that probably is why I have used a very clear background against which the image can articulate itself.

DS I don't think I can think of any other painter who has tried to resolve such a contradiction between a *malerisch* image and a vivid, uninflected ground.

FB Well, that may be because I hate a homely atmosphere, and I always feel that *malerisch* painting has too homely a background. I would like the intimacy of the image against a very stark background. I want to isolate the image and take it away from the interior and the home. $\Box \Box$

DS Going back over those long discussions about chance or accident, I've been especially struck by two of the thoughts that recur. One is your dislike of paintings looking what you call 'chancy'. And the other is your belief that things which come about by chance are more likely to seem to have a certain inevitability than things which come about by will. Can you say why you feel that an image will tend to look more inevitable the more it comes about by accident?

FB It hasn't been interfered with. And it seems to be fresher. The hinges of form come about by chance seem to be more organic and to work more inevitably.

DS Lack of interference – is that the clue?

FB Yes. The will has been subdued by the instinct.

DS You're saying that, in allowing chance to work, one allows the deeper levels of the personality to come across?

FB I certainly am trying to say that. But I'm also trying to say that they come over inevitably – they come over without the brain interfering with the inevitability of an image. It seems to come straight out of what we choose to call the unconscious with the foam of the unconscious locked around it – which is its freshness.

DS Now, you often say that the accidents which are most fruitful tend to happen at the time of greatest despair about how to go on with a painting. On the other hand, when I once asked you whether, on days when conscious operations were going well, chance operations would also be likely to be going well, you said they would. Of course that statement isn't incompatible with the others, but could you enlarge?

FB Well, there are certain days when you start working and the work seems to flow out of you quite easily, but that doesn't often happen and doesn't last for long. And I don't know that it's necessarily any better than when something happens out of your frustration and despair. I think that, quite possibly, when things are going badly you will be freer with the way you mess up by just putting paint through the images that you've been making, and you do it with a greater abandon than if things have been working for you. And therefore I think, perhaps, that despair is more helpful, because out of despair you may find yourself making the image in a more radical way by taking greater risks.

DS You've told me that half of your painting activity is disrupting what you can do easily. What is it you can do easily and want to disrupt?

FB I can quite easily sit down and make what is called a literal portrait of you. So what I'm disrupting all the time is this literalness, because I find it uninteresting.

DS And I take it that marks made with the brush can be just as disruptive as operations like throwing paint or applying a rag.

FB Oh certainly. With oil paint being so fluid, the image is changing all the time while you're working. One thing either builds on another or destroys the other. You see, I don't think that generally people really understand how mysterious, in a way, the actual manipulation of oil paint is. Because moving – even unconsciously moving – the brush one way rather than the other will completely alter the implications of the image. But you could only see it if it happened before you. I mean, it's in the way that one end of the brush may be filled with another colour and the pressing of the brush, by accident, makes a mark which gives a resonance to the other marks; and this leads on to a further development of the image. It's really a continuous question of the fight between accident and criticism. Because what I call accident may

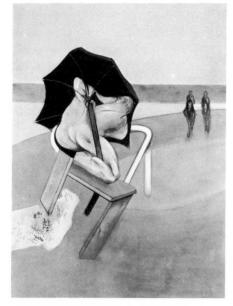

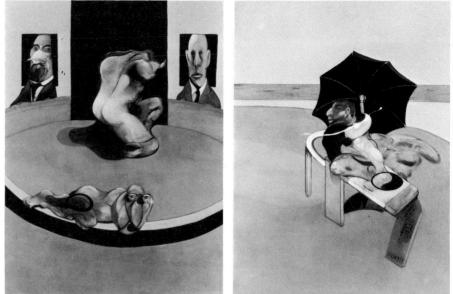

93 Triptych - May-June 1974

give you some mark that seems to be more real, truer to the image than another one, but it's only your critical sense that can select it. So that your critical faculty is going on at the same time as the sort of half-unconscious manipulation – or very unconscious, generally, if it works at all.

DS Of course, trusting to chance seems to be something that pervades the whole way you live your life. For one thing, it's very obvious in your attitude to money. At the time I first knew you, you didn't get a lot of money for a painting but, even then, the moment you sold one you'd be buying champagne and caviar for everyone in sight. You never held back. You've always seemed free of prudence.

FB Well, that's because of my greed. I'm greedy for life; and I'm greedy as an artist. I'm greedy for what I hope chance can give me far beyond anything that I can calculate logically. And it's partly my greed that has made me what's called live by chance – greed for food, for drink, for being with the people one likes, for the excitement of things happening. So the same thing applies to one's work. I nevertheless, when I cross the road, do look both ways. Because, with the greed for life, I don't play it in the way that I also want to be killed, as some people do. Because life is so short and, while I can move and see and feel, I want life to go on existing.

DS Your taste for roulette doesn't, as it were, extend to Russian roulette.

94 (Opposite) Centre panel of 93

FB No. Because to do what I want to do would mean, if

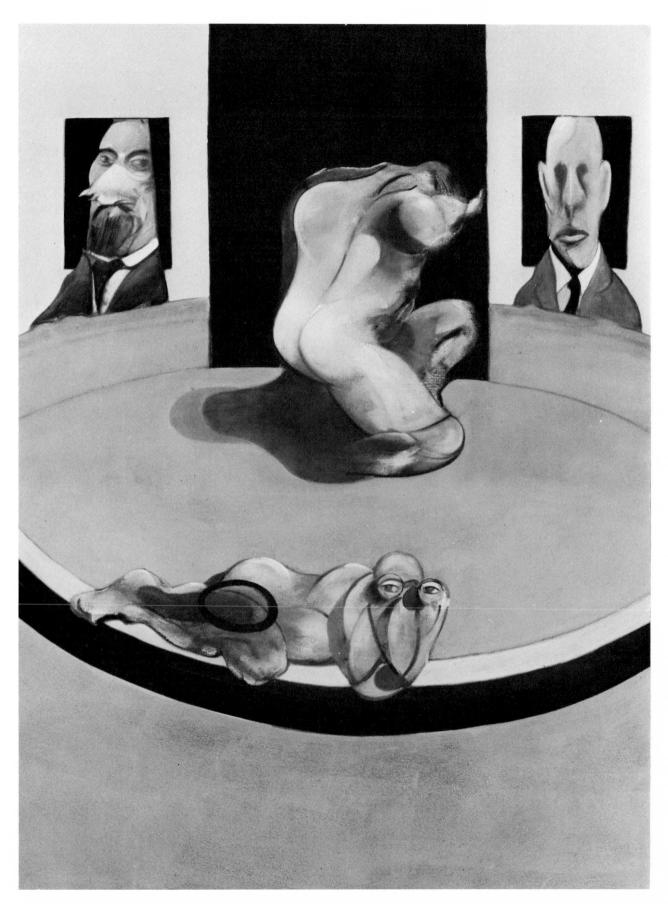

possible, living. Whereas the other day somebody was telling me about De Staël – that Russian roulette was an obsession with him and that very often he would drive round the corniche at night at tremendous speed on the wrong side of the road, purposely to see whether he could avoid the thing or not avoid it. I do know how he's supposed to have died; that out of despair he committed suicide. But for me the idea of Russian roulette would be futile. Also, I haven't got that kind of what's called bravery. I'm sure physical danger actually can be very exhilarating. But I think I'm too much of a coward to court it myself. And also, as I want to go on living, as I want to make my work better, out of vanity, you may say, I have got to live, I've got to exist.

DS When you didn't have much money but were spending it as you did, were you ever left destitute for a time? Or did something always come to the rescue?

FB Well, I have often manipulated things so that they should come to my rescue. I think I'm one of those people who have a gift for always getting by somehow. Even if it's a case of stealing or something like that, I don't feel any moral thing against it. I suppose that's an extremely egocentric attitude. It would be a nuisance to be caught and put in prison, but I don't have any feeling about stealing. Now that I earn money, it would be a kind of stupid luxury to go out and steal. But when I had no money, I think I often used to take what I could get.

DS I have the impression that following one's impulses and accepting the consequences and ignoring security isn't just the way you yourself behave; it's also a prejudice that governs your view of society. I mean that you talk as if the concept of the welfare state, with its guarantee of certain kinds of security, seems to you a sort of perversion of life.

FB Well, I think that being nursed by the state from the cradle to the grave would bring such a boredom to life. But in saying that, it may be something to do with that I have never had the morality of poverty. And therefore I can't think of anything more boring than that everything was looked after for you from your birth to your death. But people seem to expect that and think it is their right. I think that, if people have that attitude to life, it curtails – I believe this, I cannot prove it – the creative instinct. It would be

difficult to understand why. But I never believe one should have any security and never expect to keep any.

DS You feel that it's, as I said, a kind of perversion of life and its possibilities that people should seek security?

FB Well, it's the opposite of the despair about life and the despair about existence. After all, as existence in a way is so banal, you may as well try and make a kind of grandeur of it rather than be nursed to oblivion.

DS Obviously what politics is basically about is the conflict between individual freedom and social justice, and you clearly think of individual freedom as something far more important than social justice. You don't get disturbed when you see social injustice?

FB I think it's the texture of life. I know that you can say that all life is completely artificial, but I think that what is called social justice makes it more pointlessly artificial.

DS And you're not disturbed by the kinds of suffering which are endured by some people as a result of social injustice?

FB No. When you say they don't disturb me, I'm in a way very conscious of them. But I think, as I live in a country where there has been a certain amount of wealth, it's difficult to talk about a country where there has always been extreme poverty. And it's quite possible that people could be helped in extremely poor countries to exist on a plane where it was possible for them to escape from their hunger and their general despair. But I'm not upset by the fact that people do suffer, because I think the suffering of people and the differences between people are what have made great art, and not egalitarianism.

DS You're saying, then, that the thing by which a society is to be judged is its potential for creating great art, rather than something like the greatest happiness of the greatest number?

FB Who remembers or cares about a happy society? After hundreds of years or so, all they think about is what a society has left. I suppose it's possible that a society may arise which is so perfect that it will be remembered for the perfection of its equality. But that hasn't yet arisen, and so far one remembers a society for what it has created. $\Box \Box$

List of illustrations

Photographs, unless otherwise credited, were provided by Marlborough Fine Art (London), Ltd. The measurements are given in inches and centimetres, height before width.

1 (Frontispiece) Self-Portrait, 1973. Oil on canvas, 78×58 (198 \times 147.5). Collection of the artist.

2 Pablo Picasso: Untitled charcoal drawing, 1927. $13\frac{5}{8} \times 19\frac{7}{8}$ (34.5 \times 50.5).

3 Pablo Picasso: Untitled brush drawing, 1927. $23\frac{1}{2} \times 23\frac{1}{4}$ (60 × 59).

4 Three Studies for Figures at the Base of a Crucifixion, 1944. Oil and pastel on hardboard, each 37×29 (94 × 74). Tate Gallery, London.

5 Centre panel of 4.

6 Painting, 1946. Oil and tempera on canvas, $77\frac{7}{8} \times 52$ (198 × 132). Museum of Modern Art, New York.

7 Three Studies for Portrait of Henrietta Moraes, 1963. Oil on canvas, each 14×12 (35.5 × 30.5). Collection of Mr and Mrs William S. Paley, New York.

8 Three Studies for a Crucifixion, 1962. Oil on canvas, each 78×57 (198 × 145). The Solomon R. Guggenheim Museum, New York.

9 Cimabue: Crucifixion 1272–4 (inverted). Oil on wooden panel, $176\frac{3}{8} \times 153\frac{1}{2}$ (448 × 389.9). Chiesa di Santa Croce, Florence.

10 Right-hand panel of 8.

11 Study for Portrait of Van Gogh II, 1957. Oil on canvas, 78×56 (198 × 142). Collection of Edwin Janns Jr., California.

12 Van Gogh: The Painter on his Way to Work or The Road to Tarascon, 1888. Formerly in the Kaiser-Friedrich Museum, Magdeburg. Destroyed during the war.

13 Head II, 1949. Oil on canvas, $31\frac{3}{4} \times 25\frac{5}{8}$ (80.5 × 65). Ulster Museum, Belfast.

14 Pope I, 1951. Oil on canvas, 78×54 (198 × 137). Aberdeen Art Gallery and Industrial Museum.

15 Pope II, 1951. Oil on canvas, 78×54 (198 × 137). The Kunsthalle, Mannheim.

16 Pope III, 1951. Oil on canvas, 78×54 (198 × 137). Destroyed by the artist in 1966.

17 Study for Portrait, 1949. Oil on canvas, $58 \times 51\frac{1}{2}$ (147.5 × 131). Collection of Mr and Mrs Joseph R. Shapiro, Illinois.

18 Velasquez: Pope Innocent X, 1650. Oil on canvas, $55\frac{1}{8} \times 47\frac{1}{4}$ (140 \times 120). Galleria Doria Pamphili, Rome.

19 Pope, 1954. Oil on canvas, $60 \times 45^{7}_{8}$ (152.5 × 116.5). Private collection, Switzerland.

20 Study of Red Pope (Study from Innocent X), 1962. Oil on canvas, 78×56 (198 × 142). Collection of Mr and Mrs M. Riklis, New York. **21** Study for a Head, 1955. Oil on canvas, 40×30 (101.5 × 76). Private collection, London.

22 Study after Velasquez's Portrait of Pope Innocent X, 1953. Oil on canvas, $60\frac{1}{4} \times 46\frac{1}{2}$ (153 × 118). Collection of Carter Burden, New York.

23 Study after Velasquez, 1950. Oil on canvas, 78×54 (198 × 137). Destroyed by the artist in 1951.

24 Centre panel of 25.

25 Study for Three Heads, 1962. Oil on canvas, each 14×12 (35.5 \times 30.5). Collection of Mr and Mrs William S. Paley, New York.

26 Portrait of Henrietta Moraes, 1963. Oil on canvas, 65×56 (165 \times 142.5). Private collection, Germany.

27, 28 Eadweard Muybridge: Sequences of photographs from *The Human Figure in Motion*, 1887.

29 Series of photographs from K. C. Clark, *Positioning in Radiography*, London, 1929.

30 Clem Haagner: Photograph taken in the Kalahari. (*Photo:* Ardea Photographics, London)

31 Eadweard Muybridge: Page of selected photographs in some editions of *The Human Figure in Motion*.

32 Marius Maxwell: Photograph from Stalking Big Game with a Camera in Equatorial Africa, London, 1924. **33** Sergei Eisenstein: Still from *The Battleship Potemkin*, 1925.

34 Nicholas Poussin: Detail from The Massacre of the Innocents, 1630–31 (with angle altered). Oil on canvas, $57\frac{7}{8} \times 67\frac{3}{8}$ (147 × 171.1). Musée Condé, Chantilly, France. (Photo: Giraudon)

35 A corner of Bacon's studio.

36 John Deakin: Photograph of George Dyer.

37 John Deakin: Photograph of Isabel Rawsthorne.

38 John Deakin: Photograph of Lucian Freud.

39 John Deakin: Photograph of Henrietta Moraes.

40 Photographs of Bacon taken by himself in automatic booths. (Copyright Francis Bacon.)

41 Crucifixion, 1965. Oil on canvas, each 78×58 (198 × 147.5). Bayerische Staatsgemäldesammlungen, Münich.

42 Fragment of a Crucifixion, 1950. Oil and cotton wool on canvas, $55 \times 42\frac{3}{4}$ (140 × 108.5). Van Abbemuseum, Eindhoven, Netherlands.

43 Centre panel of 41.

44 Edgar Degas: After the Bath: Woman Drying Herself, 1903. Pastel, $27\frac{1}{2} \times 28\frac{3}{4}$ (69.9 × 73). National Gallery, London.

45 Study for Figure IV, 1956–7. Oil on canvas, 60×46 (152.5 × 117). National Gallery of South Australia, Adelaide.

46 Head VI, 1949. Oil on canvas, $36\frac{3}{4} \times 30\frac{1}{4}$ (93 × 77). Arts Council of Great Britain.

47 Three Studies for Portrait of Lucian Freud, 1965. Oil on canvas, each 14×12 (35.5 × 30.5). Private collection, London.

48 Three Figures in a Room, 1964. Oil on canvas, each $78 \times 57\frac{3}{4}$ (198 \times 147). Musée National d'Art Moderne, Paris (on loan from the Centre National d'Art Contemporain).

49 Right-hand panel of 48.

50 Detail from centre panel of 48.

51 Rembrandt: Self-Portrait, c. 1659. Oil on canvas, $11\frac{3}{4} \times 9\frac{3}{4}$ (30 × 24). Musée, Aix-en-Provence. The authenticity has recently been questioned by certain scholars.

52 Henri Michaux: Untitled Indian ink drawing, 1962. 29×42 (73.7 × 106.7). Formerly in the collection of Francis Bacon.

53 Landscape, 1952. Oil on canvas, $55 \times 42\frac{3}{4}$ (139.5 × 108.5). Private collection, Rome.

54 Detail from right-hand panel of *41*.

55 Furniture and rugs designed by Bacon, photographed in his studio, 1930. From a feature in *Studio*, 'The 1930 Look in British Decoration', August 1930.

56 Crucifixion, 1933. Oil on canvas, $24\frac{3}{4} \times 19$ (62 × 48.5). Trustees of Sir Colin and Lady Anderson, London.

57 Man Drinking (Portrait of David Sylvester), 1955. Oil on canvas, 24×20 (61 × 51). Private collection, Paris.

58 Study for a Portrait, 1953. Oil on canvas, $60 \times 46\frac{1}{2}$ (152.5×118). Kunsthalle, Hamburg.

59 Two Figures, 1953. Oil on canvas, $60 \times 45\frac{7}{8}$ (152:5 × 116.5). Private collection, England.

60 Two Figures in the Grass, 1954. Oil on canvas, $59\frac{3}{4} \times 46$ (152×117). Private collection, Paris.

61 Triptych – August 1972. Oil on canvas, each 78×58 (198 × 147.5). Collection of the artist.

62 Centre panel of 61.

63 Lying Figure with Hypodermic Syringe, 1963. Oil on canvas, 78×57 (198 × 145). University Art Museum, Berkeley.

64 Velasquez: Prince Philip Prosper, 1659. Oil on canvas, $50\frac{3}{8} \times 39$ (128 × 99). Kunsthistorisches Museum, Vienna.

65 Edvard Munch: *The Scream*, 1893. Oil, pastel and casein on cardboard. $35\frac{7}{8} \times 28\frac{7}{8}$ (91 × 73.5). National Gallery, Oslo. **66** Henri Fuseli: Ariadne Watching the Struggle of Theseus with the Minotaur, c. 1815. Brown wash and white body colour, $24 \times 19\frac{3}{4}$ (61 \times 50.2). Collection Mr and Mrs Paul Mellon, Upperville, Virginia.

67 Alberto Giacometti: Head of Diego, 1955. Painted bronze, height $22\frac{1}{4}$ (56.6). (Photo: Claude Gaspari, copyright Fondation Maeght, France)

68 Three Studies of the Human Head, 1953. Oil on canvas, each 24×20 (61 × 51). Private collection.

69 Detail from right-hand panel of 68.

70 Three Studies of Isabel Rawsthorne on Light Ground, 1965. Oil on canvas, each 14×12 (35.5× 30.5). Private collection, London.

71 Marcel Duchamp: Three Standard Stoppages, 1913–14. Three threads glued upon three glass panels, each $49\frac{3}{8} \times 7\frac{1}{4}$ (125.4 × 18.4); inscribed on reverse: 'Un mètre de fil droit, horizontal, tombé d'un mètre de haut. 3 stoppages étalon; apartenant à Marcel Duchamp. 1913–14.' Three flat wooden strips repeating the curves of the threads, averaging 45 (114.3) in length. The Museum of Modern Art, New York, Katherine S. Dreier Bequest.

72 Portrait of Isabel Rawsthorne Standing in a Street in Soho, 1967. Oil on canvas, 78×58 (198×174.5). Nationalgalerie, Berlin.

73 Triptych – May-June 1973. Oil on canvas, each 78×58 (198 × 147.5). Collection of the artist.

74 Right-hand panel of 73.

75 Detail from right-hand panel of 91.

76 Pablo Picasso: Houses on a Hill (Horta de San Juan), 1909. Oil on canvas, $25\frac{1}{2} \times 32\frac{1}{4}$ (65 × 81.5). Private collection, Paris.

77 Pablo Picasso: Still Life with a Violin, 1911–12. Oil on canvas, $39\frac{1}{4} \times 28\frac{3}{4}$ (100×73). Rijkmuseum Kröller-Müller, Holland.

78 Sleeping Figure, 1974. Oil on canvas, 78×58 (198 × 147.5). Collection of the artist.

79 Triptych – Studies from the Human Body, 1970. Oil on canvas, each 78×58 (198 × 147.5). Private collection.

80 Centre panel of 79.

81 Study of Nude with Figure in a Mirror, 1969. Oil on canvas, 78×58 (198 × 147.5). Private collection, Paris.

82 Lying Figure in a Mirror, 1971. Oil on canvas, 78×58 (198 × 147.5). Marlborough Galleries Inc., New York.

83 Study for Crouching Nude, 1952. Oil on canvas, 78×54 (198 \times 137). The Detroit Institute of Arts. 84 After Muybridge–Woman Emptying Bowl of Water and Paralytic Child on All Fours, 1965. Oil on canvas, 78×58 (198 × 147.5). Private collection.

85 Seated Figure, 1974. Oil and pastel on canvas, 78×58 (198× 147.5). Collection of the artist.

86 Painting, 1950. Oil on canvas, 78×52 (198.1 × 132.1). City Art Gallery, Leeds.

87 Michelangelo: Study for a putto and for the right hand of the Libyan Sibyl; sketches for the tomb of Julius II, 1511 and 1513. Red chalk, pen, $11\frac{1}{4} \times 7\frac{5}{8}$ (28.6×19.4). Ashmolean Museum, Oxford. (*Photo:* Museum) 88 Three Studies of Figures on Beds, 1972. Triptych, oil and pastel on canvas, each 78×58 (198 × 147.5). Private collection.

89 Eadweard Muybridge: Photograph from *The Human Figure in Motion*, 1887.

90 Centre panel of 88.

91 Triptych – March 1974. Oil on canvas, each 78×58 (198 × 147.5). Collection of the artist.

92 Centre panel of 91.

93 Triptych – May-June 1974. Oil and pastel on canvas, each 78×58 (198 × 147.5). Collection of the artist.

94 Centre panel of 93.

Editorial note

Interview 1 is based on a single session recorded by the BBC in October 1962. A version for radio, produced by Leonie Cohn, 'Francis Bacon talking to David Sylvester', was first broadcast on 23 March 1963; a version for publication, 'The Art of the Impossible', first appeared in *The Sunday Times Colour Magazine* for 14 July 1963; the present extended version has been edited afresh from the transcript.

Interview 2 is based on three days of recording and filming by the BBC in May 1966. A version for television was included in a film, written and directed by Michael Gill, *Francis Bacon: Fragments of a Portrait*, first transmitted on 18 September 1966; a version for publication, 'From Interviews with Francis Bacon by David Sylvester', first appeared in the catalogue of the exhibition, 'Francis Bacon: Recent Paintings', at Marlborough Fine Art, London, in March-April 1967; the present extended version has been edited afresh from the transcripts.

Interview 3 is based on three sessions recorded privately in December 1971, July 1973 and October 1973.

Interview 4 is based on two sessions recorded privately in September 1974.

I am greatly indebted to Shena Mackay for her invaluable assistance with the editing of the transcripts.

I am also grateful to Hugh Davies, Andrew Forge and Christopher White for their advice, to Philippa Barton for her skilful handling of awkward secretarial tasks, and to Marlborough Fine Art for providing photographs and information.